MANGA ART

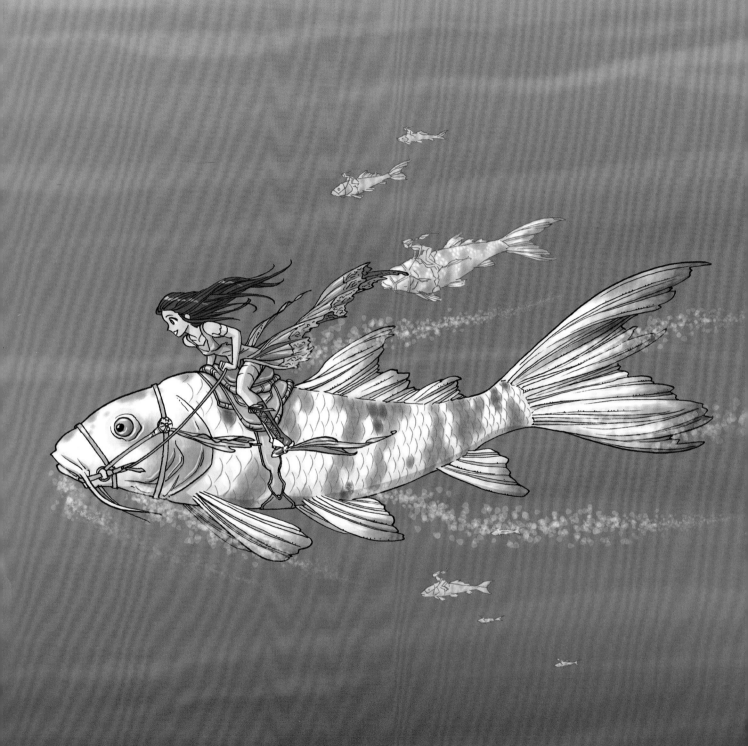

MANGA ART

Inspiration and Techniques
from an Expert Illustrator

MARK CRILLEY

WATSON-GUPTILL PUBLICATIONS
California | New York

THIS BOOK IS DEDICATED TO MY PARENTS,

ROBERT AND VIRGINIA CRILLEY.

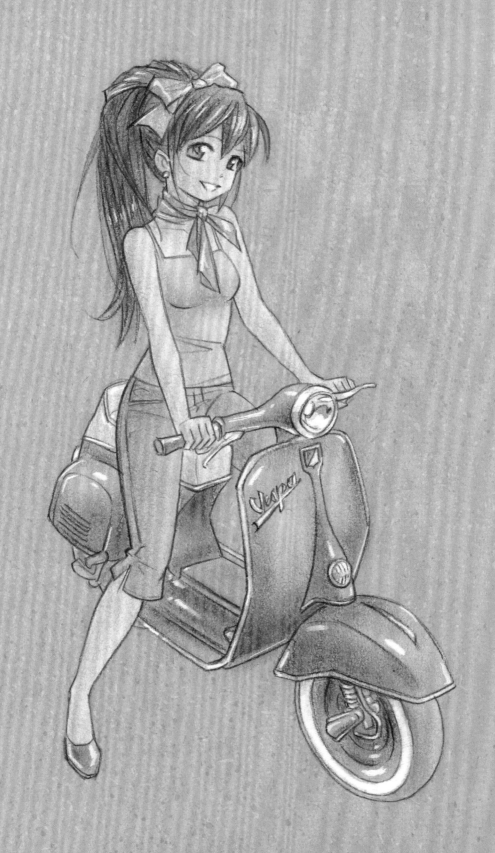

CONTENTS

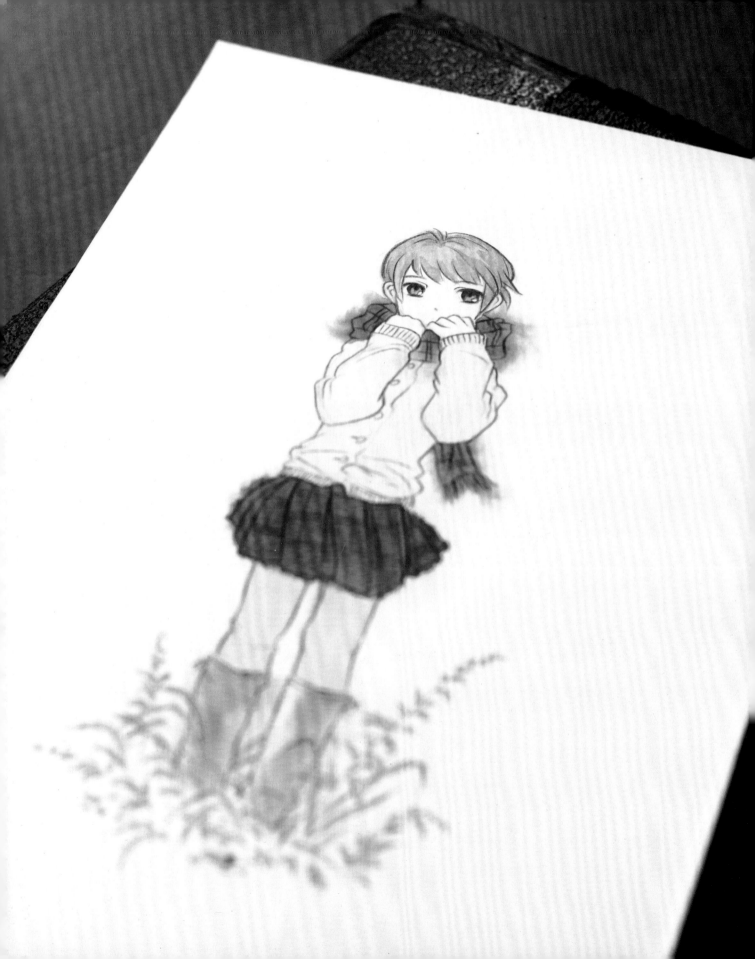

INTRODUCTION

When I was a little kid, my parents always kept stacks of white paper on a shelf in the kitchen, low enough that the paper was easily within my reach. Not far from that paper supply was a cup full of pencils, and, next to that, an electric pencil sharpener. My parents knew I loved to draw. They knew, in fact, that there was basically nothing else I would rather do. I was kind of obsessed with it.

All day long, I'd have a pencil in hand, filling page after page with whatever captured my imagination at the time—monsters, superheroes, rocket ships, race cars, you name it. I was free to push myself to the limits of my imagination; with an endless supply of paper and pencils nearby—and provided I'd finished my homework—no one would ever tell me to stop.

And so I continued merrily drawing away through elementary, middle, and high school. Of course, once I decided to major in art at Kalamazoo College, things became a little more structured. There might be an assignment to tackle a certain subject, or a directive to draw in a certain way. Years later, when I became a published author and illustrator, there were naturally further limitations: outlines were discussed, plans were made, drawings were submitted for approval, and so on. The days of just sitting down and drawing what I wanted to had inevitably come to an end. Such is the way of the world.

Or is it?

A couple of years ago, I pitched a book idea to Watson-Guptill Publications, proposing to create a book of illustrations. There was just one thread intended to unite them all: they should be in a manga style, or they should relate to Japan and the world of manga in some way. To my great pleasure, the folks at Watson-Guptill said, "Let's do it."

And I was a child once more.

The illustrations you are about to view were created in an atmosphere of complete artistic freedom. The publisher entrusted me with creating the book

that I wanted to create. This freedom meant that I was able to follow my muse, day after day, week after week, and make the kind of illustrations I wanted to. I came up with the ideas. I decided the sizes and shapes of each image. I settled on which art supplies to use for drawing the lines and for adding the colors.

It was all up to me. No one said they needed to come in and look over my shoulder. No one said, "Mark, can we see some rough drafts and run them by the committee?" It wasn't like that. I just sat down and started making art. Truly, it was like being a kid again.

The stack of paper had become pads of Strathmore Bristol board, and the pencils . . . well, they remained pencils: Dixon Ticonderoga—the very same brand I had used as a child. But they were now joined by other art supplies. Man oh man, were they ever joined by other art supplies! I pulled out every type of drawing and coloring tool I had at my disposal for this project: watercolors, colored pencils, gouache (an opaque water-based paint), pastels, pen and ink, computer coloring—nothing was ever very far from my fingertips. I was determined to put the "mixed" back into "mixed media."

The organizational principles of this book developed organically. I reached a point one or two months in where I was able to stand back and see that all these pictures had as their primary focus one of five things: characters, Japanese culture, science fiction, unusual concepts, or efforts at working in a particular art style. And so I arranged things into the five chapters that lie before you.

Let's look at the manga aspect. At the heart of the book is manga-style artwork, but perhaps not in the way that you might expect. These are not images that meticulously mimic the art of published Japanese illustrators. It's not a book that's meant to fool you into thinking it was originally published in Tokyo. The name Crilley—I need hardly explain—is not Japanese. (It's Irish, if you must know.)

My approach was to take the manga style and be a kind of mad scientist with it. What happens when you mix manga art with styles you would normally see in children's picture books? What would a manga illustration look like if it were designed by Gustav Klimt? Can manga art be created with loose lines? Or scratchy lines? What about no lines at all? This book contains pictures that answer all of these questions, and many, many others.

Some people (people stricter than me) will even say that some of these pictures don't qualify as "real" manga art. That's not for me to decide. But I can promise you one thing: you will never reach a point

where you can predict, more or less, what's waiting for you on the next page. This book is designed to keep you guessing. If I've done my job right, these illustrations shouldn't look like they're all trying to do the same thing. Heck, some of them shouldn't even look like they were done by the same *guy*. I wanted this book to be like The Beatles' *White Album*: zigging and zagging all over the place, but somehow—just barely—holding together as a single creation.

One last thing: this is more than just a collection of pictures. There's quite a lot of writing in this book, and most of it goes well beyond simply introducing you to the artwork. My goal was to inspire creativity, and to pass along specific information about my techniques that you could then use in creating your own work. In reading the various descriptions and short essays in the pages ahead, you will learn all about the ideas behind these pictures, and what made me want to make them. You'll learn about the decisions I made along the way, the things I chose to do or chose not to do, and why. And you'll learn quite a lot about the art supplies I used, and how each of them contributed to the appearance of the final images.

This book was a dream project for me. That's not to say it was easy. Indeed, of the three books I've created for Watson-Guptill, this one was by far the most

challenging and time-consuming. But what a thrill it was to get back to my roots as an artist. To push myself up against every limit I could think of. To reach deep into my imagination and way back into my own memories, pulling it all up from within me and laying it down on the page. What an honor it was to be allowed to go chasing after inspiration day after day. I woke up every morning with just one job in front of me: to create and create and create.

Thank you all so much for reading my words and looking at my pictures. Making this book brought me struggles I will soon forget, and joys I will always remember. May your own creative endeavors do the same for you.

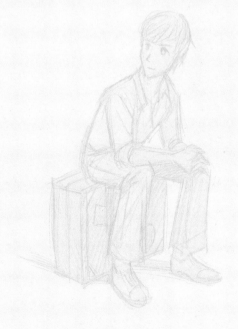

CTERS

1
CHARACTERS

I've always felt that creating characters comes from a natural instinct. Human beings probably started doing it as soon as they could scrawl pictures on the wall of a cave. When I speak at schools or anime conventions, I sometimes ask, "How many of you have created your own characters?" It's not uncommon for every hand in the audience to go up.

No two people create characters the same way. Some artists choose to base their characters off of people they know. Others formulate characters based on different aspects of their own personalities. Some grant themselves complete freedom to create fanciful characters that bear no resemblance to actual humans. Others won't be satisfied unless their characters are utterly believable in every way.

Within the realm of inventing characters, the creative process behind manga character creation forms an interesting subcategory. There is artistic freedom involved, to be sure. But you are following the path of an established tradition. There's a certain stylized approach to body proportions—especially in regards to the proportions of the facial features—that one sees in genuine manga illustrations published in Japan. I feel it's important to study the work of real manga artists, and to gain a sense of what the rules are before you start bending them (let alone breaking them).

In terms of the manga characters awaiting you in this first chapter, you'll see me coming at the manga style from a variety of angles. Many of the illustrations feature highly traditional manga-style faces: the eyes, nose, and mouth carefully balanced so as to resemble artwork made by illustrators working in Japan. Others are the result of me putting my spin on the manga style, mixing Japanese and Western traditions with my own artistic sensibilities. Even in these cases, though, I'm trying to be respectful of the manga tradition, and not just completely go my own way.

Casual observers of manga may claim that "all manga characters look the same." That is, of course, not

true. The more you study the work of various manga illustrators, the more you realize that each artist brings his or her own instincts to the drawing table. People looking at the pictures in this chapter may say, "These are manga-style illustrations," but they will also have to say, "These are Crilley-style illustrations." There's just something about the way I draw—the lines, the colors, the compositions—that shows up in these drawings, one way or another. And that is exactly as things should be.

If by chance these pictures inspire you to pick up a pencil and start creating manga characters of your own, by all means go for it. You will find yourself on a path that I and so many others have followed for years, one that is rich in both challenges and rewards. Keep at it long enough and you'll be the one putting your spin on the manga style, expanding the tradition, and deepening it in a way that only you can.

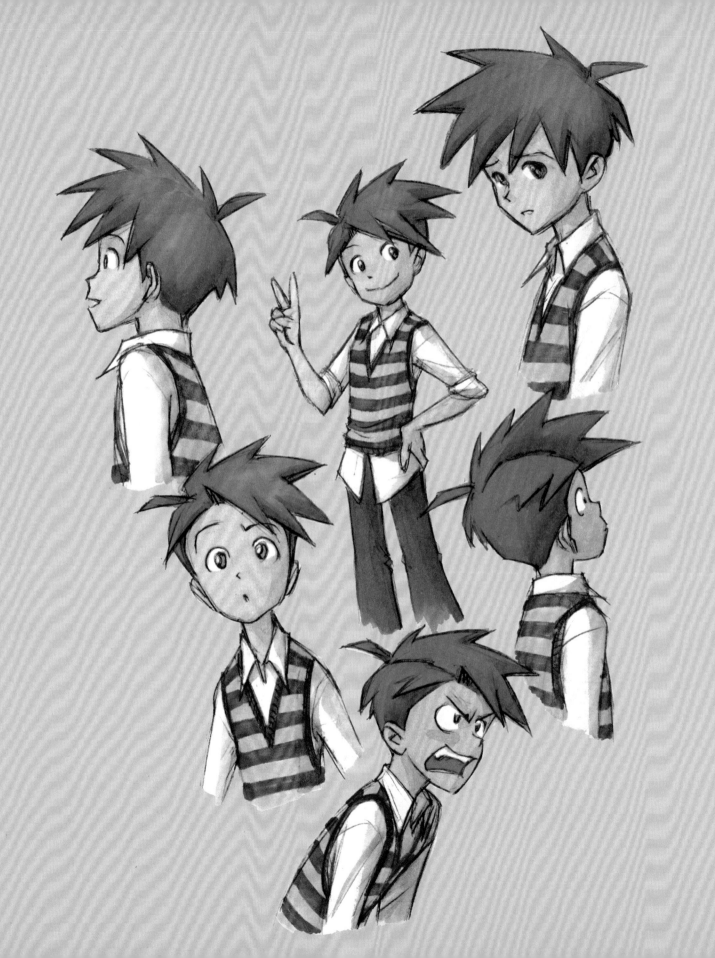

THE BOY WITH THE BLUE HAIR

When you create manga characters, it's important to force yourself to draw them from different angles and in different emotional states. The main goal is to prepare yourself for the challenges of drawing those characters in an actual story. If you're lucky, though, you may find your preparatory drawings are themselves worthy of artistic consideration.

For this illustration, I wanted to celebrate the beauty of such manga prep work. Will I ever use this character in a story? Maybe. Maybe not. But the picture itself, with its various versions of the same sweater-vested boy, has a certain energy and liveliness to it that I feel allows it to stand on its own.

I did all my line work in pencil, then dashed in the color with markers, trying to keep things loose. After that, I scanned the image into Photoshop and applied a muted background color to help the artwork "pop" a little. I can't claim to have put hours and hours into this one, but I'll tell you this: I like it more than a lot of other pieces I've worked on for days!

SUMMER

The seasons often play an important role in manga stories. I chose to put them front and center in my graphic novel series *Miki Falls*, splitting the saga into four different books: *Spring*, *Summer*, *Autumn*, and *Winter*.

This young woman bears more than a passing resemblance to the main character of *Miki Falls*, Miki Yoshida. I liked the idea of suggesting the character's environment—by way of the wind working upon her clothing and hair—without actually drawing the environment.

Again I turned to markers for this one, choosing light colors for a sun-bleached effect. I did my line work with a brown colored pencil rather than a black one.

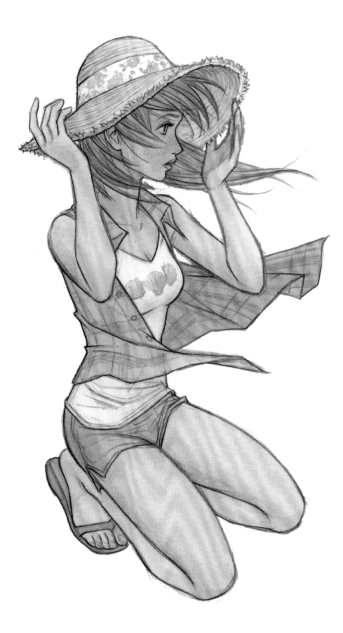

Summer
pencil, marker, colored pencil;
9½ x 5½ inches (24.1 x 14 cm).

OPPOSITE
The Boy with the Blue Hair
pencil, marker, colored pencil,
white gouache, computer coloring;
9¼ x 6¼ inches (23.5 x 15.9 cm).

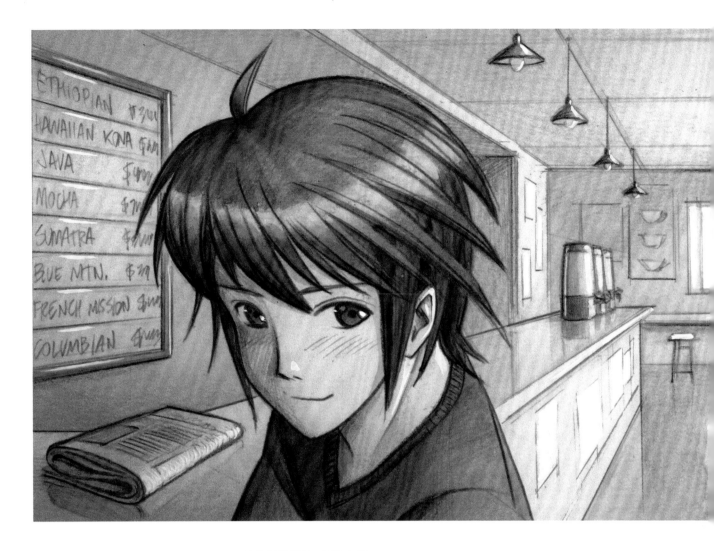

Coffee Shop
pencil, marker, colored pencil,
white gouache, computer coloring;
5 x 10 inches (12.7 x 25.4 cm).

COFFEE SHOP

Some manga characters are so unusual in their appearance that you'd think they were beings from another world. (Indeed, depending on the story, they may in fact *be* from another world.) I enjoy drawing such characters and, in this book, you'll see a number of them. But I also like drawing more down-to-earth types: people you could imagine living next door to, or seeing at your corner coffee shop.

For this illustration, I took that latter idea and ran with it. What would the "manga guy at a coffee shop" look like? Well, I figure one thing is for sure: he'd be all about the color brown. I liked the idea of presenting this character in his natural habitat, looking out at us as if to say, "Have you tried the cinnamon dolce latte?"

I did all my line work in graphite pencil, leaving things a little rough for a warm, earthy look. I used brown markers for his hair and sweater, then scanned everything in and used Photoshop to tint the entire image brown. Touches of white gouache, applied with a fine-tipped brush, help to convey the sunlight glinting off objects throughout the image.

Your Turn

Try making a drawing of a character with a location as your background. For the character you draw, you could use a quite different location from my coffee shop: someplace more mysterious or even one that is frightening.

Ear Muffs
pencil, colored pencil,
computer coloring;
4½ x 6 inches (11.4 x 15.2 cm).

EAR MUFFS

This illustration was inspired by art I created for one of my YouTube videos, "How to Draw a Manga Girl." For that version, I used sketchy lines and a variety of colors to create a loose and slightly impressionistic final image. This time I wanted to see what the same pose would look like in black and white, and with more tightly controlled lines.

The eyes are an important part of what makes manga characters so engaging. Using an ordinary graphite pencil, I devoted special care to building up the tone within each of the irises, creating a gradient fade—a very gradual change in the color's darkness—from top to bottom. I used a black colored pencil to outline the entire picture, but went extra dark in the area of the pupils and eyelashes, so as to make the eyes the main focal point of my illustration.

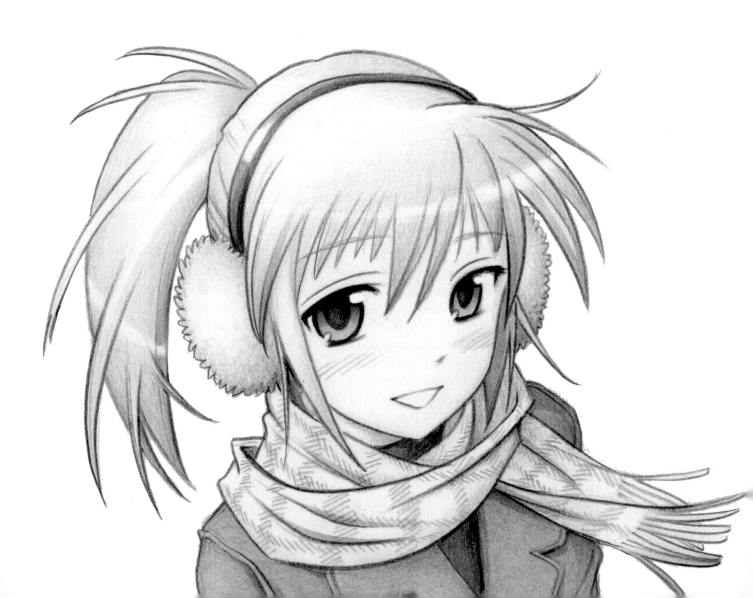

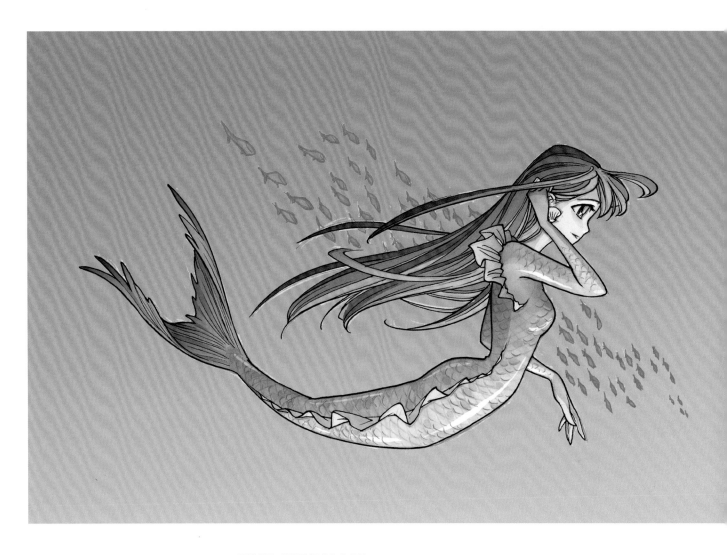

The Mermaid
pencil, pen and ink, computer coloring;
5¼ x 10¼ inches (13.3 x 26 cm).

THE MERMAID

I've never written a story involving mermaids, so I haven't been called upon to draw them very often. Still, I've always been a little intrigued by the concept. As a result, I figured it was high time I sat down to figure out what a Crilley-style mermaid might look like.

Maybe it's just me, but I've always felt there was something a little corny about there being a superclear dividing line between the "fish part" and the "human part," as you've probably seen in so many mermaid illustrations. So, for my mermaid, I chose to apply a more blended approach. Her scales extend all the way up across her torso and arms.

I started with a rough pencil sketch, and then did the inks on a separate piece of paper—scanning both into the computer to begin the coloring process in Photoshop. By allowing a little of the initial pencil rough to show through around the edges, I was able to sneak a little organic scruffiness into this otherwise supersmooth illustration.

THE WINTER FIELD

Manga may be best known for its cute characters with big, shiny eyes. However, there is a whole different side to the manga world: one that is darker, and much more serious in tone. For this illustration, I wanted to create a mysterious and otherworldly character, one whose design was definitely not going to include big, shiny eyes.

It was a frigid February day as I began work on this piece. The gray skies inspired me to create a character who would seem entirely at home in such weather: a figure as cold and lifeless as the climate I was experiencing.

I did all my line art in pen and ink, but quickly moved to Photoshop to complete this illustration. I knew computer coloring would be the perfect means of producing the icy clarity I wanted for this piece. Though I'd originally planned a nearly colorless image, I couldn't resist a little splash of color with his red scarf.

OPPOSITE
The Winter Field
pen and ink, computer coloring;
12¾ x 9½ inches (32.4 x 24.1 cm).

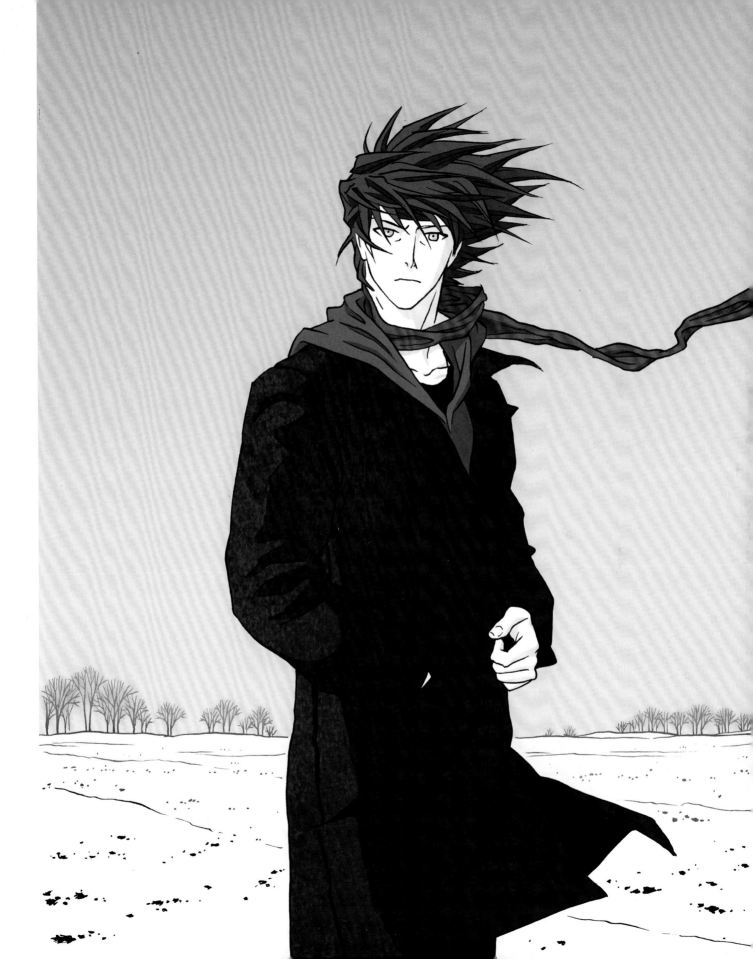

PIGEONS

Character creation is about more than just drawing a person and giving that person a certain look. You need to breathe life into your character. To do that, you need to have a strong sense of who he or she is. One way of getting to the heart of a character you've invented is to try drawing the character doing something he or she enjoys.

I was sketching this gentle-looking soul with a scarf around his neck, when suddenly it hit me: *Pigeons. This guy likes to feed pigeons*. It was such an oddly specific idea, I knew that it had to be right. So I pulled out my pencils and watercolors and got to work.

Watercolor proved the perfect art supply for this illustration. Its soft colors and subtle textures seemed a good match for the kind-hearted character I was creating. Though I adjusted things in Photoshop—mainly just darkening the grass to get more contrast with the bench—this is very much an "old-school" illustration, created almost entirely with traditional art tools.

OPPOSITE
Black Dress
pencil, colored pencil,
computer coloring;
6½ x 11½ inches (16.5 x 29.2 cm).

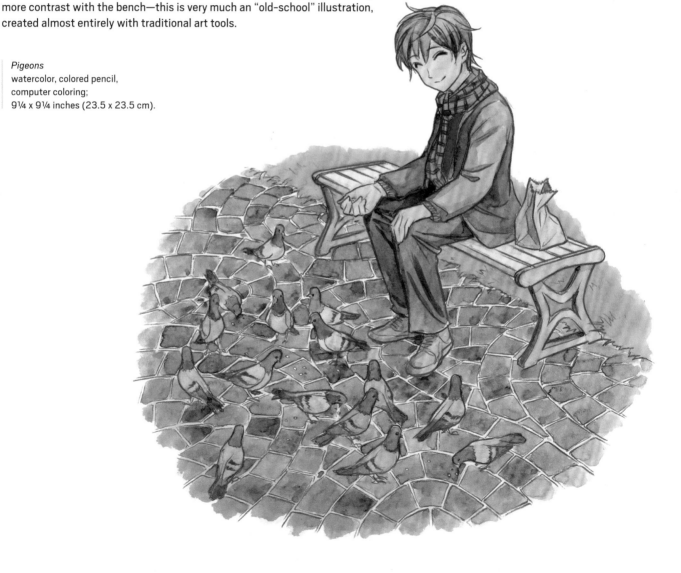

Pigeons
watercolor, colored pencil,
computer coloring;
9¼ x 9¼ inches (23.5 x 23.5 cm).

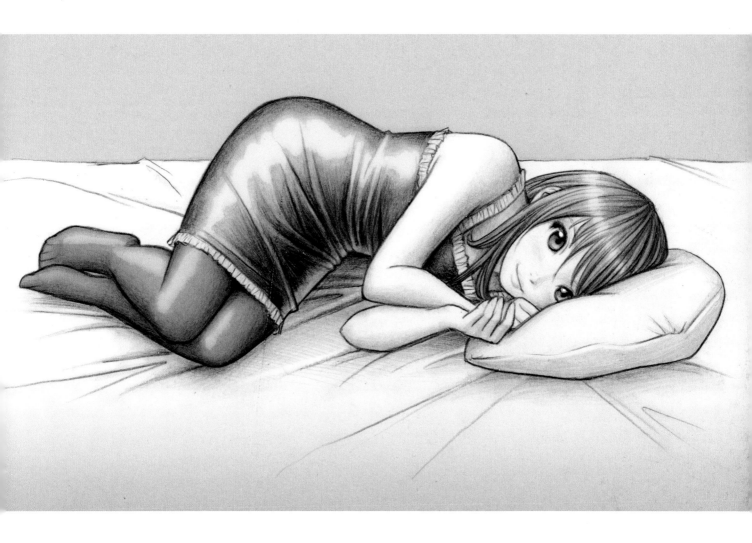

BLACK DRESS

As an artist, one of the things I am constantly working on is drawing poses. Human anatomy is a very complicated subject and, no matter how many years I practice, I know there will always be further work to do in this area. This illustration was born of my interest in learning to draw relaxed-looking poses. Let's face it: you can't get more relaxed than when you're lying down.

I consulted different photographs to come up with the basics of the pose. In some manga styles, the anatomy becomes quite exaggerated and cartoony; however, I wanted something a little more realistic for this picture. I relied on pencil and black colored pencil for the fundamentals of the image, then scanned the drawing into my computer for a few final touches in Photoshop. I achieved the shiny effects on her dress and stockings digitally. I also added a pale gray tone for the background.

Your Turn

Do a drawing of a particular pose, basing it on either a photo or real-life observation. Later, try drawing the pose a second time without looking at anything, and see how well you were able to commit the pose to memory.

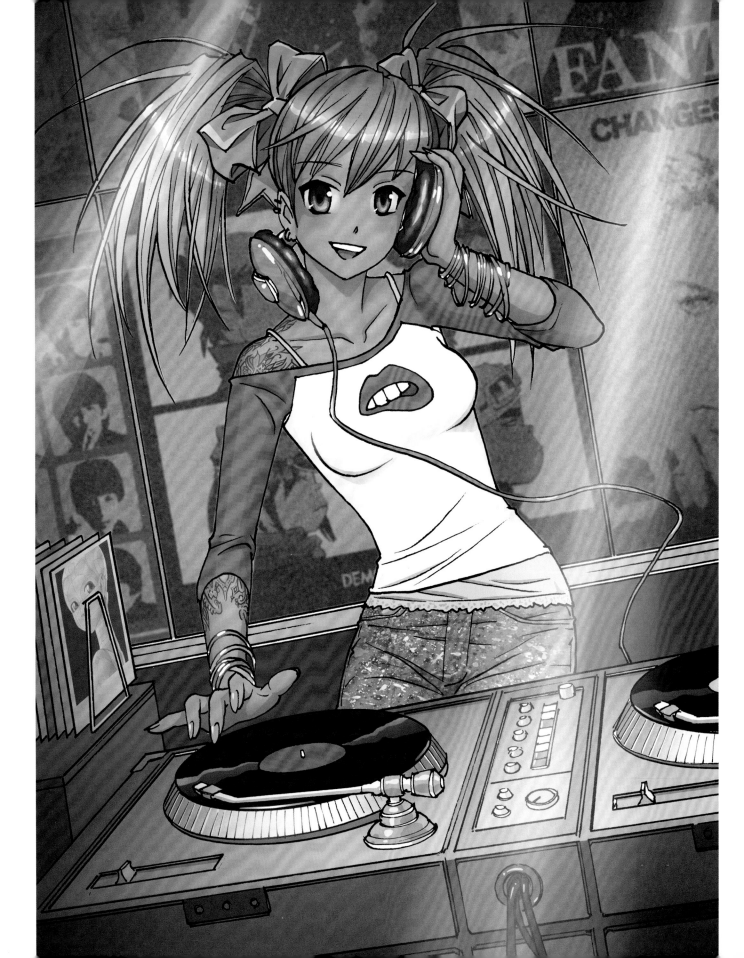

OPPOSITE
Vinyl Violet
pen and ink, computer coloring;
9 x 6½ inches (22.9 x 16.5 cm).

VINYL VIOLET

Music has always been a pretty big part of my life, so I thought I might try an illustration that brought my love of music and manga character design together. The result is this rather free-spirited disc jockey character whose musical tastes—judging by the posters on the wall—are uncannily similar to mine.

I envisioned her as a fan of bright colors, and knew Photoshop would allow me the freedom to play around with lots of possible color combinations. Once I'd rendered all the lines in pen and ink, I scanned the image into Photoshop and cut loose with purple and turquoise. Have a look at her tattoo, as it is a rare example of something I drew digitally (that is, with a Wacom pad and stylus). I was heavily into the computer coloring process when I thought, *I should've given her a tattoo*. Better late than never: I freestyled the whole thing from scratch, making it up as I went along.

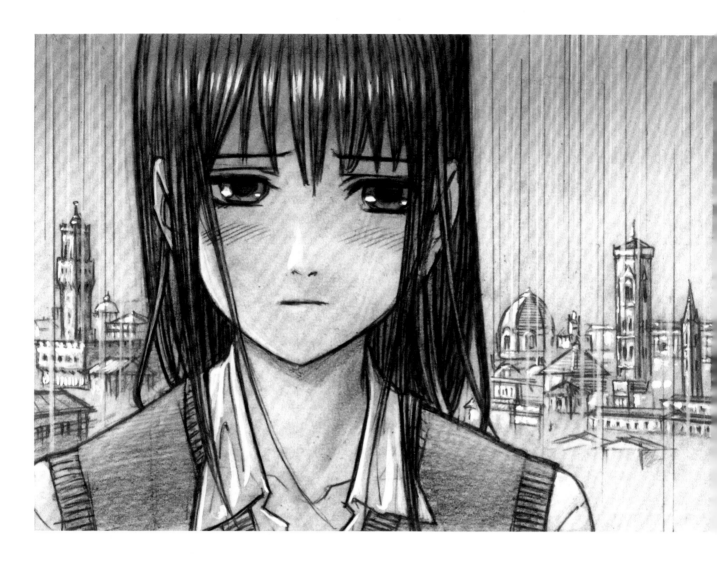

A RAINY DAY IN FLORENCE

A Rainy Day in Florence
pencil, colored pencil, white
gouache, computer coloring;
5¼ x 9½ inches (13.3 x 24.1 cm).

Drawing manga characters is always a pleasure, but I find the process even more enjoyable when I can imagine some sort of story to go with the character. For this illustration, I pictured a Japanese college student who was given the opportunity to study in Florence. The obvious thing to do was to show her smiling and soaking up the sun. But where's the fun in doing the obvious thing?

I arranged the composition to resemble a panel from within a manga story: the kind where the main character is deep in contemplation and readers are able—by way of a voiceover speech balloon—to read her thoughts. Using reference photos to get the details right, I drew the skyline of Florence in the background, then used a white colored pencil to add vertical lines of various lengths to signify rain.

For fun, I decided to capture some of my progress on this illustration in a video, including the application of white gouache highlights to add contrast throughout the piece. You can find that video on YouTube by searching for "Question & Answer Video #27."

LOLITA GIRL

Japan is a land of many subcultures, all of them kept alive by fiercely committed fans. One such subculture is that of *Lolita fashion*, a style of dress inspired by Victorian and Edwardian clothing styles. Having never drawn a Lolita-style character before, I thought I'd challenge myself to create one, just for this book.

The worst thing you can do when wading into an unfamiliar subculture is to get the details wrong. There's a chance that I've done exactly that! Still, I did study photos and illustrations, trying my best to design a proper Lolita outfit without doing a wholesale copy of any one particular dress. I chose to repeat certain elements throughout the costuming, such as dark ribbons and white, lacy borders, so as to give her a unified look from head to toe. After creating the basic illustration in pen and ink, I decided to keep the coloring process simple: markers and nothing else.

Lolita Girl
pen and ink, marker;
10 x 4¼ inches (25.4 x 10.8 cm).

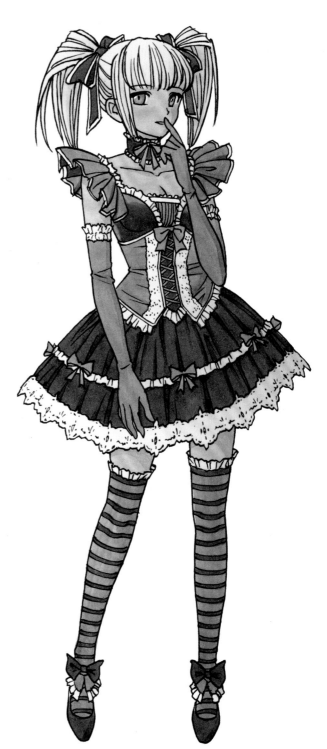

WALLFLOWERS

For this illustration, I revisited artwork from a YouTube video I created called "How to Draw Manga Eyes." I'd always been pleased with the character I created in that picture. She had a youthful cheeriness about her that projected optimism and confidence. But I felt the final image looked a little unfinished. It needed a background of some kind.

It's no fluke that I ended up choosing a floral pattern. I have always been fascinated with patterns. In this case, I did an Internet search to compare various wallpaper patterns until I found one that seemed like a good match for my art.

Rather than copy the pattern just as it was, I moved its components around, tailoring it to fit the blank spaces in my picture. To keep the flowers from becoming too distracting, I did all my line work in pencil, limiting my use of black colored pencil to the foreground. A touch of computer coloring allowed me to darken the pattern and push it further into the background.

Wallflowers
pencil, colored pencil,
computer coloring;
4½ x 7½ inches (11.4 x 19 cm).

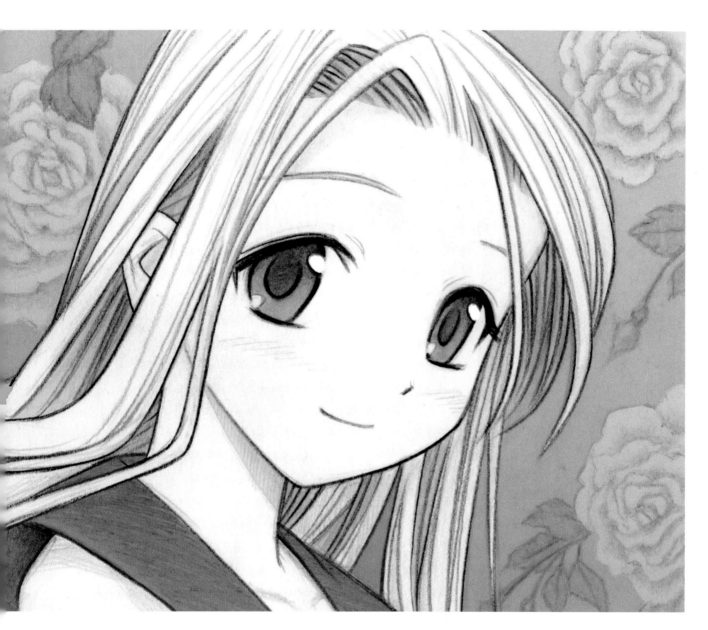

Your Turn

Create an illustration of a character that uses some sort of pattern as its background. Consult reference or just invent a pattern from your imagination. Try to draw your character with darker lines, so that it remains the main focus of the image.

SNUGGLING

I based this illustration on artwork that I created for a YouTube video, "How to Draw People Snuggling." My main goal with the video was to offer advice on drawing a certain type of romantic pose. Once I got into the drawing process for the book, though, I found that an additional aspect of the picture took on special importance: its lighting. If I could capture the look of late-afternoon sunlight falling upon this happy couple, I knew it would greatly enhance the appearance of coziness in the scene.

I used markers and colored pencils to get the foundation of the image in place. Then I pulled out my tube of white gouache to add highlights with a watercolor brush. These dabs of opaque white paint, carefully applied across the top of the sofa, along the lengths of the characters' arms, and especially across their hair, convey the look of sun pouring in from a nearby window.

Snuggling
pencil, colored pencil, white gouache, computer coloring;
4¼ x 7¾ inches (10.8 x 19.7 cm).

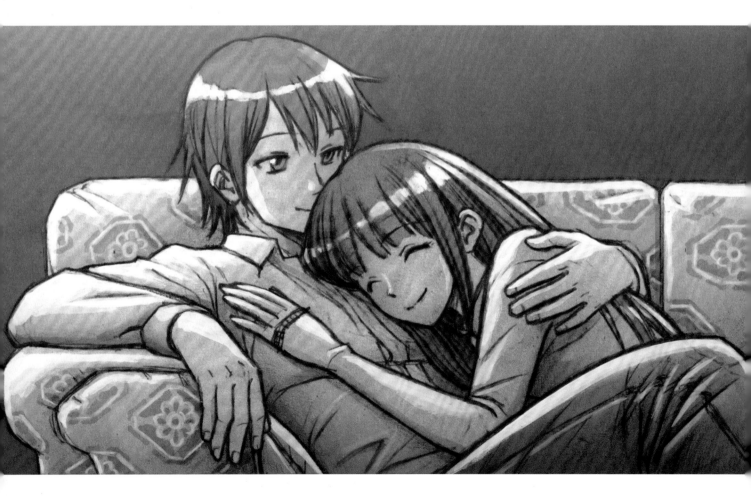

MIKI FALLS
My Crash Course in Manga Character Illustration

My first published books, *Akiko* and *Billy Clikk*, were not drawn in a manga style. It wasn't until my third project, a series of graphic novels in 2007 collectively called *Miki Falls*, that I first tried to emulate manga-style artists. It was a natural-enough choice. The story of *Miki Falls* is set in Japan, with an all-Japanese cast of characters, and its plot has many of the same elements as an old-school Japanese high school romance. There was just one problem: I'd never drawn in the manga style before, and was in many ways utterly clueless as to how it was done.

So I headed to the library and to the bookstore. I got as many legitimate manga books as I could. I looked at the popular titles of the day—*Naruto*, *Vampire Knight*, *Fullmetal Alchemist*, *Fruits Basket*, and others—but I also looked at manga whose real heyday had been a decade or so earlier: *Marmalade Boy*, *Ranma ½*, and *Oh My Goddess!* I did study after study of the manga illustrations that I admired, carefully copying various drawings just as they appeared in published books. I did my best to gain an understanding of what made the manga style tick.

It was an exciting time for me as an artist. Here I was, several books into my career, completely reinventing myself as a comic book storyteller. Studying the art of *shoujo* manga—comics aimed mainly at a female readership—was particularly enlightening. I saw that the shoujo artists created pages in which characters could break entirely free from panel borders, their contours cutting across the whole page in bold and beautiful ways. I leaped at the idea and incorporated it into my own work, creating page layouts that would have been unimaginable for me just a year or two earlier.

Looking back, I can see that I embarked on the final illustrations for *Miki Falls* before my training was complete. The first one or two books in the series featured art that I would probably rework substantially if I had the chance. But as the series progressed I found my footing, and by the time I was working on the fourth and final book—*Miki Falls: Winter*—my ability to draw manga-style characters had improved considerably.

I learned a lot from working on *Miki Falls*. In many ways, every illustration in this book owes a debt to it. If you're thinking of making your own manga series, I wholeheartedly recommend the "manga crash course" approach I used. Go to the source—genuine published manga books—and learn everything you can from them. Drawing manga characters will change you in ways that go well beyond your method of drawing eyes or hair. If you're like me, it will prove a pivotal turning point in your life as an artist.

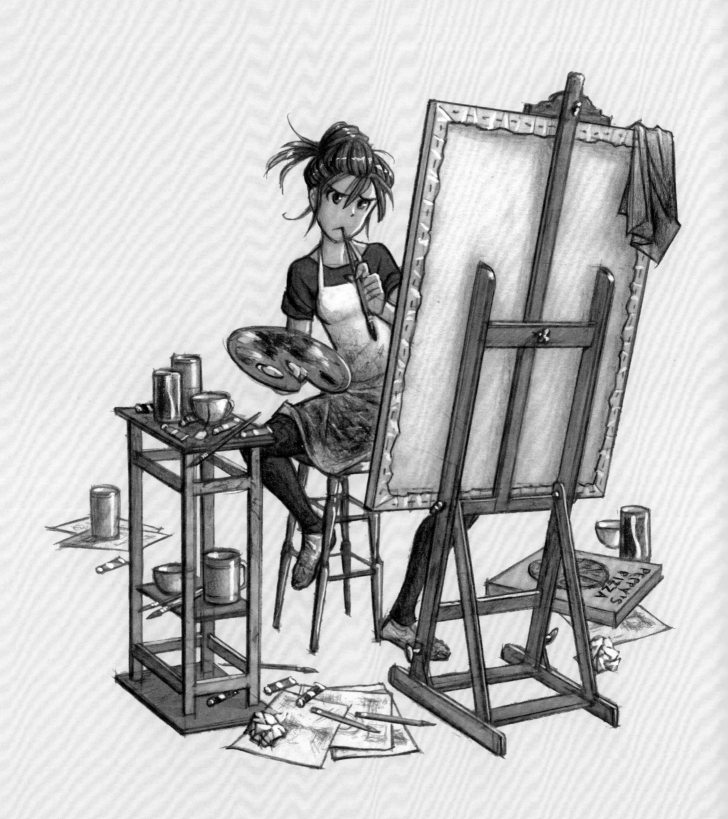

THE PAINTER

With this picture, I wanted to portray a manga character in the middle of her working day, surrounded by the tools of her trade. I did a fair amount of painting back in college, so I thought I'd relive those days a bit by making this character an old-school oil painter. Rather than give away what she was creating, I decided to use a point of view that forces each viewer to come up with his or her own idea of what appears on the artist's canvas.

I opted for brown colored pencil for my final line work, so as to give the whole illustration a soft-edged look. I felt the details could take this illustration to an interesting place, supplying narrative qualities to the picture as each small part of it told a story. The stains on her apron show us how long she's been at it, and the pizza box suggests she doesn't take breaks for very long, not even for eating.

OPPOSITE
The Painter
pencil, marker, colored pencil,
white gouache, computer coloring;
8 x 7½ inches (20.3 x 19 cm).

THE GIRL NEXT DOOR

I enjoy playing around with different ways of drawing manga characters, doing my best to never have two that look identical. With this character, I made her eyes quite large, widely spaced, and placed higher on the head than I usually do. The hair is more naturalistic and believable than, say, the boy's hair in *Coffee Shop* (page 10).

I could have added color to this image, but something held me back. The combination of graphite and black colored pencil gave the image an easygoing simplicity that I liked. So I used the pencil's eraser to create highlights on the hair and left it at that. Sometimes less is more.

The Girl Next Door
pencil, colored pencil;
7¾ x 5 inches (19.7 x 12.7 cm).

OPPOSITE
Mask of Metal
pencil, marker, colored pencil,
white gouache;
5¾ x 10 inches (14.6 x 25.4 cm).

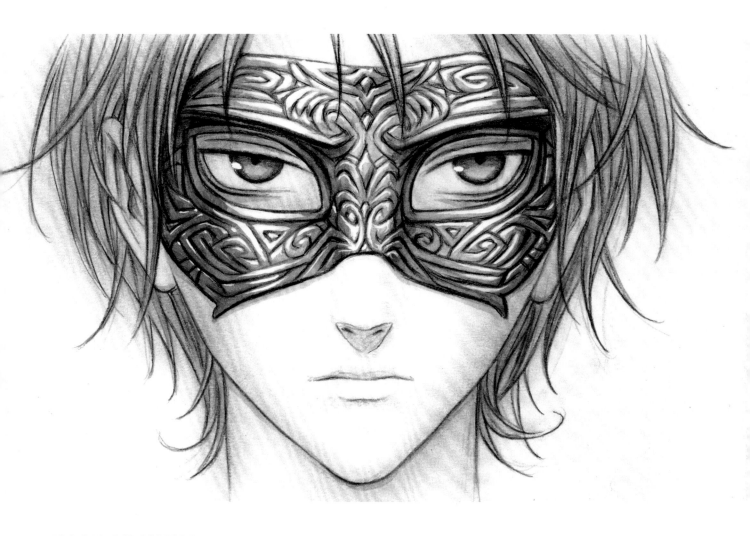

MASK OF METAL

When I create manga characters, I always make choices about what I should reveal about them and what I want to keep hidden. I thought a masked character could be an interesting way to explore this idea in illustrated form. You can see what the character looks like—the mask doesn't conceal very much. Still, the presence of the mask creates an air of mystery about the character, and may leave you wanting to know more about him.

I tried a stylistic experiment with this illustration. By making his mask gray and everything else various shades of brown and orange, I created this weird tension between the two different parts of the image. It's as if the mask is on a different plane of reality. As an artist, it's worth playing "mad scientist" every once in a while and taking a gamble on an unorthodox choice. You never know: it may result in a new approach that you can apply to other illustrations in the future.

Your Turn

Try creating an illustration in which two parts of the image are colored in two different ways. For example, in one part, your coloring could be very tight and controlled, and in the other part, quite loose. Allow yourself to experiment, rather than playing it safe.

Chibi Time!
pen and ink, computer coloring;
5¼ x 4¼ inches (13.3 x 10.8 cm).

CHIBI TIME!

Throughout this book, you will find examples of the *chibi* style—a cartooning method manga illustrators sometimes use in which characters are given large heads and tiny bodies. The idea is to present a character in a cute, fun way, often for the purposes of conveying a particular emotional state.

This illustration presents a character in a simple standing pose, so that those unfamiliar with the chibi style can gain a sense of its unique approach to body proportions. The picture began as a pen-and-ink illustration. Then I scanned it into Photoshop and began building up layers of digital color, aiming for a smooth, soft look. You may find yourself wondering, *Where's the nose?* Well, the answer is that chibi characters are often drawn without noses. My theory is that is helps focus attention on the eyes and mouth—facial features that play the biggest roles in displaying emotion.

YUMI

In my manga series *Miki Falls*, I knew the story's protagonist, Miki, would need a best friend: someone she could confide in as the mysteries of the story began to unfold. The character I eventually came up with was Yumi, a lively and impulsive sort whose unique fashion sense led me to design her in funky clothes and sporting an even funkier hairstyle.

This illustration of Yumi places her in a traditional Japanese environment, inviting viewers to see the contrast between her modern style and the old-fashioned world she grew up in. Though I used a wide variety of art supplies to create it, far and away the most important were the watercolors. This is the coloring medium I most often use when I need an organic, textured look. When I want a picture to look more smooth and unblemished (as I did in the area of the sky, for example) I turn to computer coloring.

OPPOSITE
Yumi
pencil, watercolor, marker,
pen and ink, computer coloring;
10¼ x 9¾ inches (26 x 24.8 cm).

The Castle
pencil, colored pencil,
computer coloring;
5 x 8½ inches (12.7 x 21.6 cm).

THE CASTLE

I sometimes hear from young artists who struggle with drawing hair. It's no surprise: drawing hair accurately can be a painstaking and time-consuming task. Happily, manga characters are often drawn in a very stylized way. As a result, there's no need to hold yourself to the standards of photorealism when rendering their hair, or indeed any of their other attributes.

With this illustration, I decided to draw a manga character whose hair was conveyed almost entirely by way of a single *contour line* (a line that follows along the edge of a shape without extending into the shape's interior). I worked out the basic shape of the hair with an ordinary pencil, drawing individual strands all around the edges, but avoiding any details in the middle. Next, I added quite a bit of shading, and created a highlight by erasing back to the white of the page in a single horizontal streak.

Next time you're struggling with drawing hair, give this "contour-only" approach a try, and see if you like it.

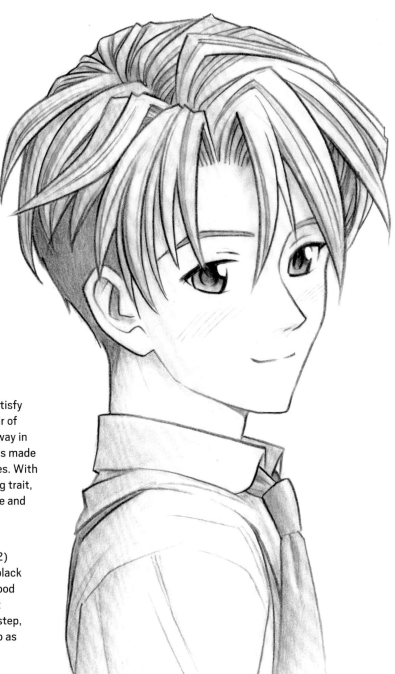

THE GOLDEN BOY

Drawing just the contour of the hair will never satisfy many manga artists. They want to render the hair of their characters in a much more detailed way, a way in which every strand—if not each individual hair—is made clear to the viewer by way of carefully placed lines. With this character, I wanted the hair to be his defining trait, so I put extra time into planning out the structure and arrangement of the various strands.

I chose to execute the illustration with the same combination of tools I used in *Ear Muffs* (page 12) and *The Girl Next Door* (page 28): graphite and black colored pencil. That combination always looks good to me, and I love that it involves art supplies that are about as inexpensive as can be. For my final step, I tinted the image yellow-brown in Photoshop, so as to give the character a bit of a golden glow.

The Golden Boy
pencil, colored pencil,
computer coloring;
7¾ x 4¼ inches (19.7 x 10.8 cm).

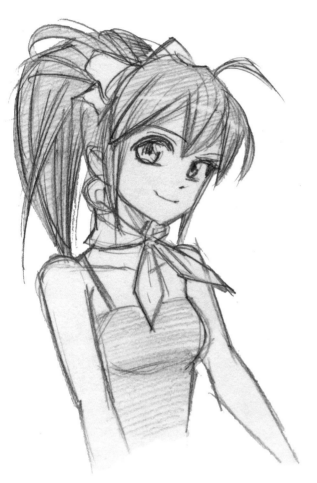

VESPA

When I'm creating manga characters, I will, of course, give thought to their hairstyles and the clothes that they wear. But there are other ways of revealing a character's personality. For instance, a character's preferred mode of transportation is another element to consider. I figured this slightly retro-looking young woman needed a retro-looking vehicle, and my mind went straight to an Italian classic: the Vespa.

I knew the smooth, shiny surface of the bike would be a natural for digital coloring. I drew the picture in pencil, inked all the lines, and then scanned the image into my computer so that Photoshop could help me do the rest. I can't stress how helpful it is to use photo reference for an illustration like this one. To get all those details just right, I needed a crash course in "Vespa anatomy," and that's exactly what I got by studying lots and lots of photographs.

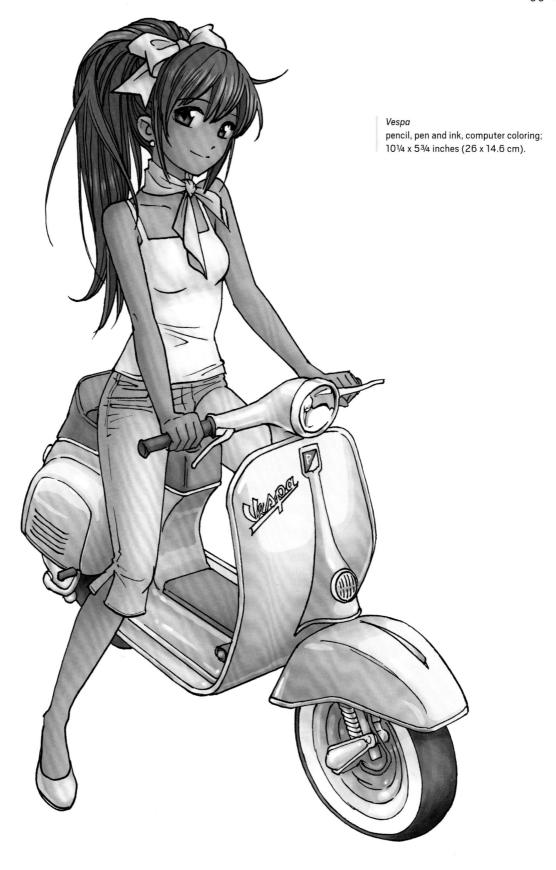

Vespa
pencil, pen and ink, computer coloring;
10¼ x 5¾ inches (26 x 14.6 cm).

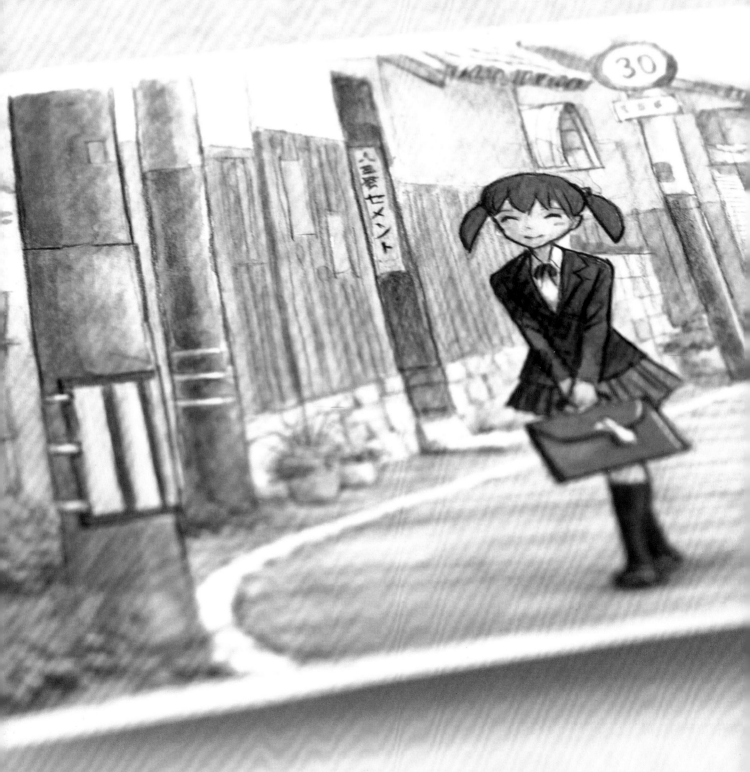

2
JAPAN

Some visitors to Japan are struck by how modern it is, and may even voice disappointment about how much of the old traditional culture has been supplanted by Western ways of doing things. I must say I have quite the opposite reaction. I am constantly impressed with how much of old Japan survives. Yes, you will find gas stations and convenience stores on any average street. But follow the alleyway between them, and you may well stumble onto a beautiful little temple or the green seedlings of a freshly planted rice paddy.

It is indeed these more traditional Japanese elements that are of most interest to me, rather than the bright neon lights of life in the heart of Tokyo. So, naturally enough, when I set about creating a series of illustrations based on a Japanese theme, the vast majority of them ended up paying tribute to the Japan of yesteryear. In the pages that follow, you will see an ancient stone staircase, a flowery kimono, a traditional public bath, and a mailbox that you might have been surprised to come across in the twentieth century, let alone the twenty-first.

I am not the only one who has a soft spot for the old Japan, clearly. One of my favorite films from famed animator Hayao Miyazaki, *My Neighbor Totoro*, is steeped in such nostalgia. It is set in the late 1950s, and its location—deep in the countryside—guarantees that no busy streets or office buildings are seen anywhere in the film. On the contrary, the audience feels transported to an idealized vision of Japan as it once was long ago: an unhurried land of thatch-roofed farmhouses, pretty little roadside shrines, and children playing with airplanes made from balsa wood. You can detect the influence of *Totoro's* vision of Japan in almost every book I've illustrated since I first saw that film, and you will certainly see it in the artwork created for this chapter.

But, of course, no portrait of Japan is complete if it is limited strictly to things found in museums. I've included an illustration of a railway platform that brings the viewer a bit more into the modern world (see page 60). There are chibi-style pictures of an office worker and a graffiti artist. And though my rendering of a high school classroom interior isn't

exactly futuristic looking, it's not radically different from what you'd find in Japan right now.

I enjoyed the process of creating all the different illustrations you'll find between the covers of this book, but the ones in this chapter have a personal aspect that sets them apart, born as they were of my connection to Japan (more on that on page 55). As I worked on these images, I felt that I wasn't just creating pictures, I was making little tributes to various aspects of Japanese culture and conveying my feelings about them.

I hope you enjoy my manga-style vision of Japan. Is it unbiased? Far from it: it's about as biased as you can get. I'm a big fan of Japan, and I can't help seeing the place through rose-tinted glasses. But all these pictures are from the heart, and if you gather them together, they go a long way toward capturing the affection I feel toward Japanese culture.

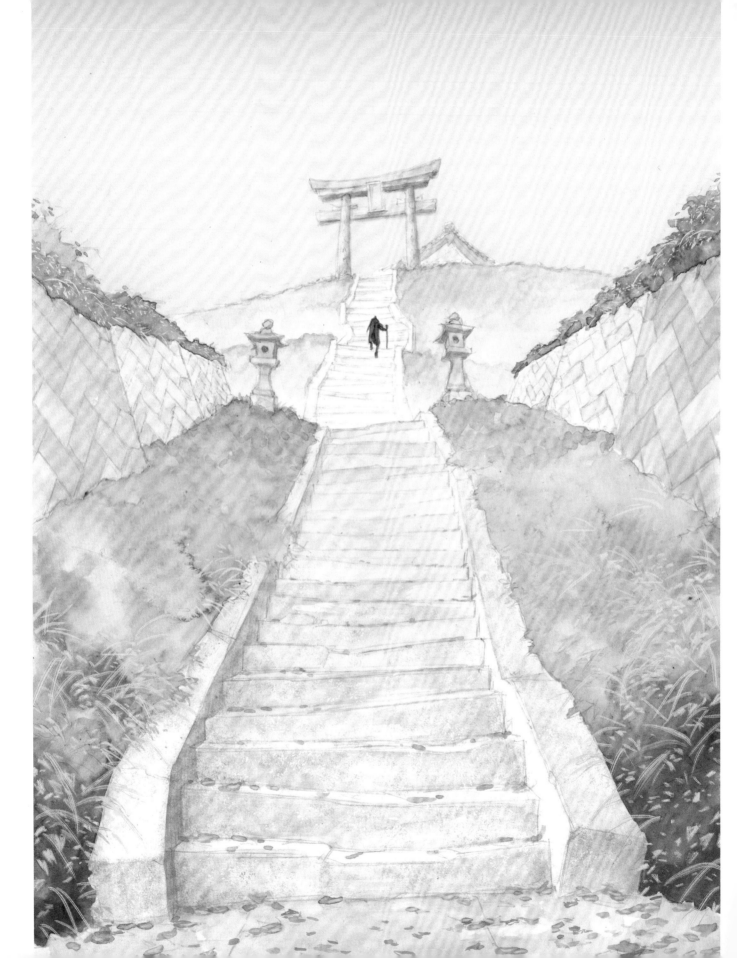

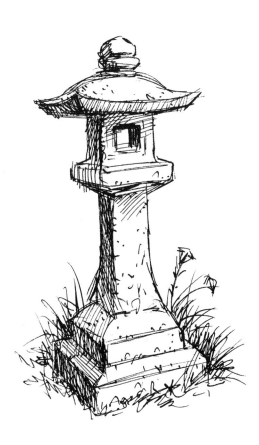

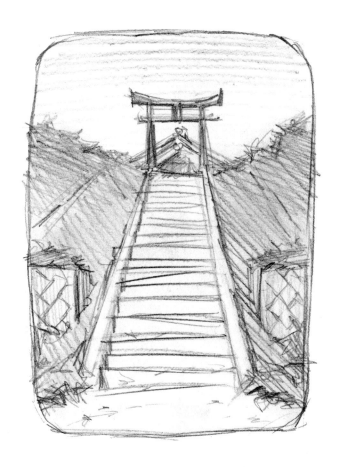

OPPOSITE

The Steps to the Temple
pencil, watercolor, colored pencil,
computer coloring;
11 x 14 inches (27.9 x 35.6 cm).

THE STEPS TO THE TEMPLE

In Fukuyama, Japan, where my wife's parents live, there is a temple at the top of a nearby mountain that we go to visit at least once every time we're in town. Half the fun is in the journey that you have to make to get there: a stone stairway that has more than three hundred steps from top to bottom.

For this illustration, I wanted to pay tribute to those steps, but also allow myself the freedom to do something other than an exacting portrait of them. So I imagined a temple of my own invention, set high on a treeless hill, its gateway creating a bold silhouette against the sky. I decided to include a figure way up near the top of the image, to help the viewer imagine him- or herself making the climb.

I knew pretty early on that I wanted watercolor to be the foundation of this picture, since it would allow me to create interesting, organic splotches of color within the areas of grass flanking the steps. But I was curious to see what effects I could achieve by way of Photoshop as well. All the blades of grass you see in the foreground were done in the computer, drawn with quick strokes of the stylus across the surface of my Wacom tablet. Another computer-generated element is the soft gradient blue of the sky, which is the sort of effect that you can create in Photoshop with just a few clicks of the mouse.

HENOHENOMOHEJI

Contrary to popular belief, not everyone in Japan is good at drawing anime or manga characters. But there is one character that everyone in Japan can draw flawlessly, and that's the *henohenomoheji*. It is a face composed entirely of hiragana, the most basic phonetic symbols that every Japanese person learns as a child. Indeed, if you look at the word "henohenomoheji" as it is written in Japan (へのへのもへじ) you can see each of the lines that make up the face.

As I played around with ways of working the henohenomoheji into an illustration, I hit upon the idea of presenting it as the work of a mischievous graffiti artist. When it comes to demonstrating your graffiti skills, you could hardly make a worse choice than this guy has. It's the one drawing that is famous for *not* requiring skill.

To create the effect of black spray paint, I came to the paper with black pastel, taking full advantage of that medium's ability to blur at the edges. For coloring the graffiti artist, I decided to go with Photoshop. To keep things simple, I used bold, flat colors that present him as if he were a TV cartoon character. The idea was to reduce the number of colors and add only a minimal amount of shading, so as to turn him into a symbol: fun and memorable, rather than bogged down with excessive detail.

Henohenomoheji
pen and ink, pastel, computer coloring;
5½ x 8½ inches (14 x 21.6 cm).

Your Turn

Instead of going for serious subject matter, try drawing something cartoony and fun. Focus on the humor of the image, rather than anything relating to realism or accurate proportions.

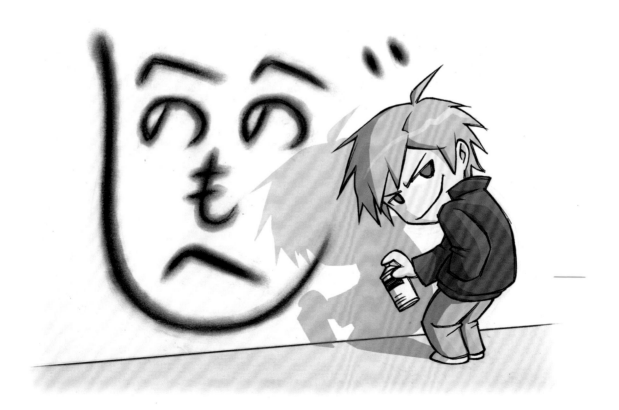

RAMEN

Now, I don't want to say that I was hungry while I worked on this book. But looking back over these pictures, there's no getting around the fact that an awful lot of them deal with food! For this one, I chose to focus on ramen. Something about this humble dish symbolizes ordinary Japanese life to me. It's never very fancy, and it's never hard to find. It's a quick bite to eat that everyone can grab before getting back to work. I've heard some Japanese people say that ramen is "the hamburger of Japan." It certainly occupies a similar position within the nation's cuisine, and is every bit as woven into the fabric of everyday life.

For this picture, I show a high school boy slurping up a nice big mouthful of noodles, with a ramen bowl in hand. I bring the viewer into the picture by having the boy raise his eyes to meet the viewer's gaze.

I chose a somewhat minimalist approach for this illustration: not too many lines, not too many colors. I did put a little extra time in on the boy's eyes, though. I used three different shades of green within each iris, and added three white highlights as well. I wanted his eyes to be striking, for them to startle you a bit as he catches you in the act of watching him.

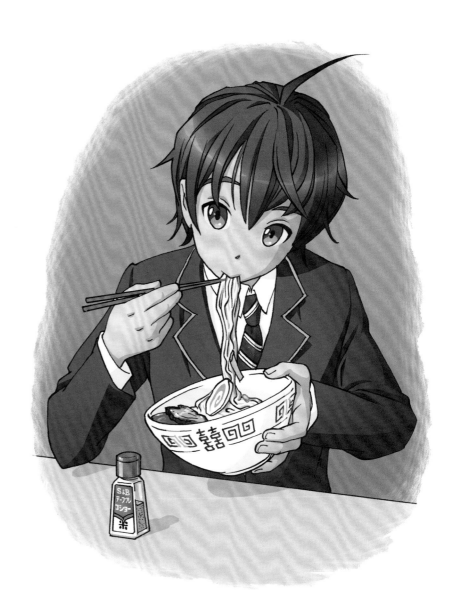

Ramen
pen and ink, computer coloring;
7½ x 6½ inches (19 x 16.5 cm).

CHU

Chu is the first of three chibi illustrations featured in this chapter that I adapted from drawings created for YouTube videos. This one comes from a video titled, "How to Draw a Chibi Kiss on the Cheek."

I did the original drawing entirely in ordinary pencil. In revisiting this image, I brought in a variety of other materials. For the color palette, I decided not to use a wide range of colors but instead to limit myself to shades of pink and purple. This method can provide an interesting "less-is-more" approach. The narrow pinkish spectrum seemed especially appropriate for this Valentine-like image.

The Japanese word you see to the right of the art is, a sound effect: *chu*, or the sound of the kiss itself. In this sense, the illustration is firmly rooted in the tradition of printed manga storytelling, in which sound effects pop up out of thin air whenever they are needed.

Chu
pencil, marker, colored pencil,
white gouache;
5¾ x 6½ inches (14.6 x 16.5 cm).

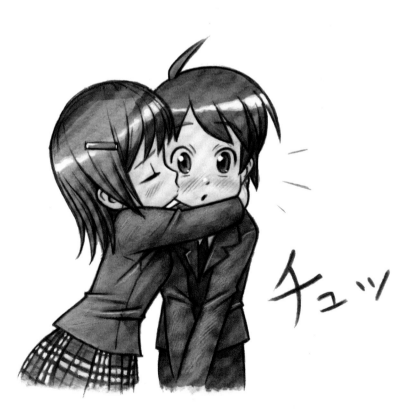

Your Turn

Try re-creating this chibi pose with different characters: either characters of your own creation or chibi versions of famous manga characters that you enjoy drawing.

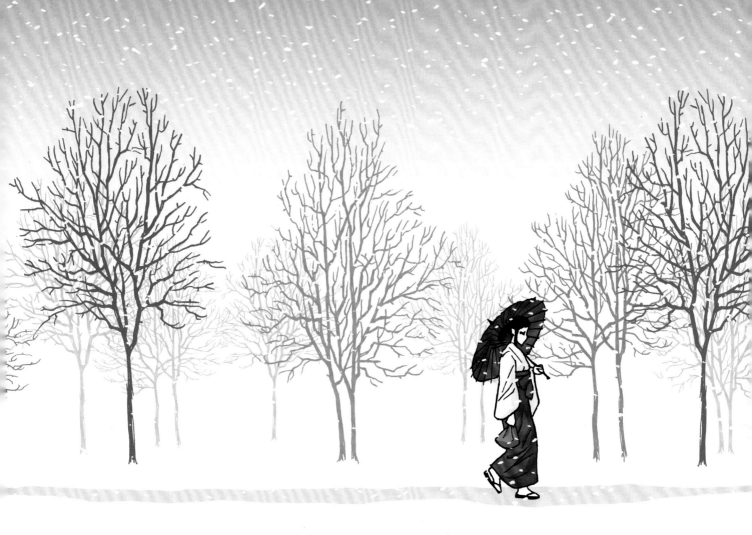

RED UMBRELLA

As I sat down to create illustrations for this chapter, I found myself wanting to use at least one of the images to portray the sort of wintery weather I often saw when I lived in Iwate, deep in the north of Japan.

The first and most important decision I made in the creation of this picture was selecting its shape. By making it decisively horizontal in orientation, I was able to convey a feeling of stability and calm in the final image. The red found in the figure and the umbrella naturally becomes the focal point, but in such a way as to call attention to how small the person is in contrast to the landscape.

This is definitely one of the most purely digital illustrations in this book. Yes, it began with pen and ink. But using Photoshop allowed me to draw just four or five trees, and then copy, paste, and flip them around to create a dozen or more with just a few clicks of my mouse. From there, it was a relatively simple matter of altering the colors and scaling them in size to create the effect of trees gradually receding into the distance.

Red Umbrella
pen and ink, computer coloring;
8 x 14 inches (20.3 x 35.5 cm).

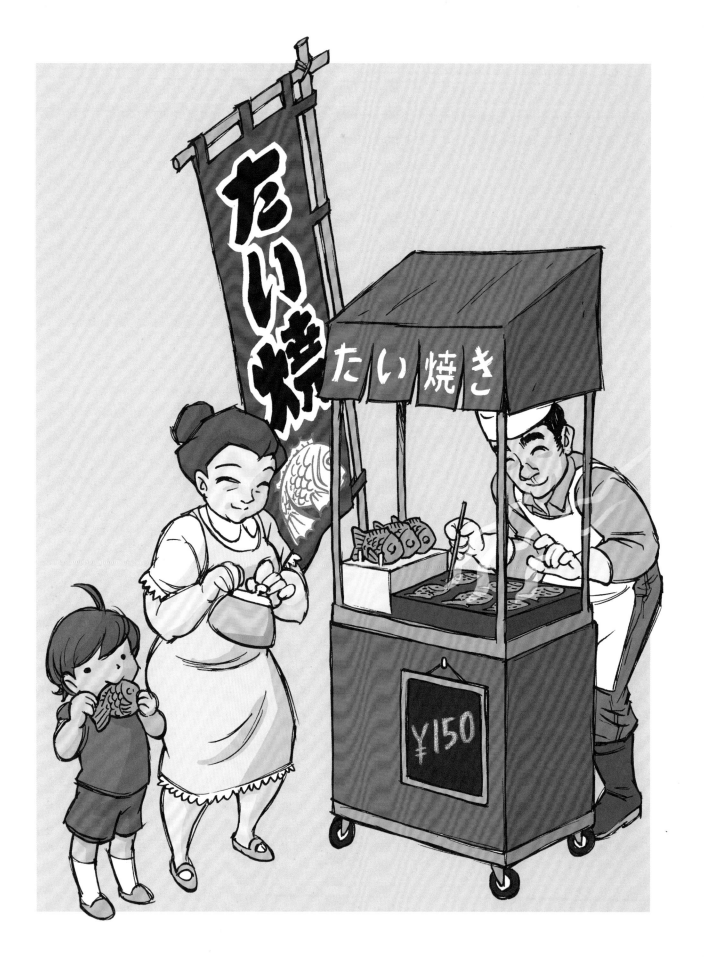

THE TAIYAKI MAN

I've always loved roadside food stalls, and the ones in Japan are all the more interesting to me, since they often sell things unavailable in the West. One such food is *taiyaki*: a Japanese treat consisting of sweetened red bean paste—*anko*—cooked within a donut-like shell. Taiyaki is cooked into the shape of a fish by way of heated cast-iron molds. If you are in Japan for any length of time, you will come across a taiyaki stand eventually.

For this illustration, I wanted to capture some of the nostalgic pleasure of buying food from such a roadside stall. I briefly considered using a realistic drawing style, but that approach seemed a little too serious. I needed something more friendly and childlike, so I chose a cartoony look, one that allowed for lots of simple, curved lines and big, flat areas of color.

I began with pen and ink, then scanned the image into Photoshop to add color. I especially enjoyed reproducing the look of classic Japanese vertical banner signage, traditionally attached on two sides to bamboo poles so that the sign can flap in the breeze. The combination you see here of red background, black lettering, and white borders around the lettering is a common one in Japan, and in many ways that combination determined the whole color scheme of this piece.

OPPOSITE
The Taiyaki Man
pen and ink, computer coloring;
11 x 8 inches (27.9 x 20.3 cm).

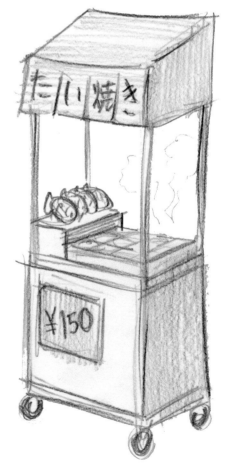

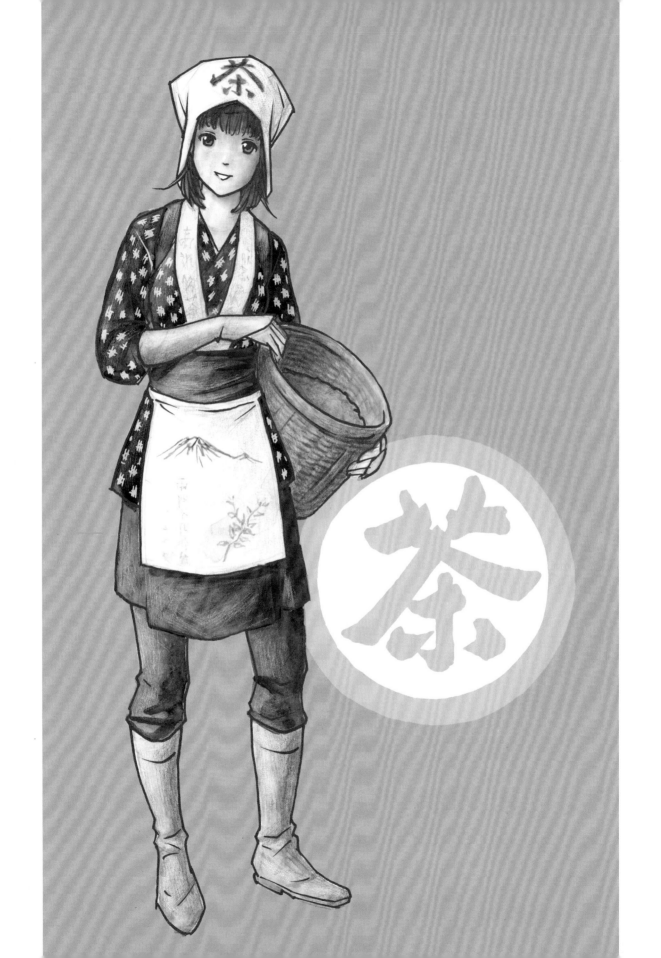

THE TEA LEAF HARVEST

You can't get much more Japanese than green tea. For people in Japan, it is as much a part of daily life as coffee is in the West. For this illustration, I decided to focus not on the green tea itself, but on the hardworking people who make the drinking of green tea possible.

I began with a simple pencil drawing of one of these plantation workers, using photo reference to get the details of her clothing right. Then I used watercolors to provide a base layer of color throughout the illustration. Even with the art still looking quite unfinished, I scanned it into the computer and added more colors digitally.

I created a separate drawing of the Japanese character for "tea," brought it into Photoshop, and positioned it beside the figure. One of the last things I did was to change all the line art from black to brown, which I feel adds to the old-fashioned feeling of the illustration.

GLOMP!

I adapted this illustration from art created for my "How to Draw a Chibi Glomp!" video. I wish I could state with great authority the origins of this word "glomp," but I'm not sure I can. Suffice to say, someone somewhere decided the action of a person giving another person a great big hug needed its own sound effect, and "glomp" was enlisted to do the job.

In addition to the aforementioned sound effect, I decided to add text in hiragana near the girl's head: *daisuki*, which may be translated as "I love you."

For such a simple drawing, I ended up using a surprisingly wide variety of art supplies. Markers provided the base, while a black colored pencil provided the line work. Though ink is the most common medium for laying in black lines, colored pencils leave lines with a slightly rough edge to them that I find appealing for certain projects.

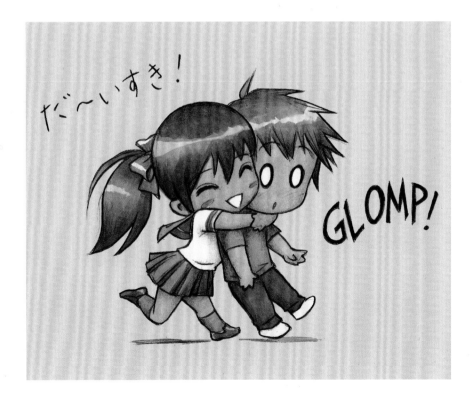

Glomp!
pencil, marker, colored pencil,
white gouache;
4¾ x 8 inches (12 x 20.3 cm).

OPPOSITE
The Tea Leaf Harvest
watercolor, pen and ink,
computer coloring;
10 x 6¼ inches (25.4 x 15.9 cm).

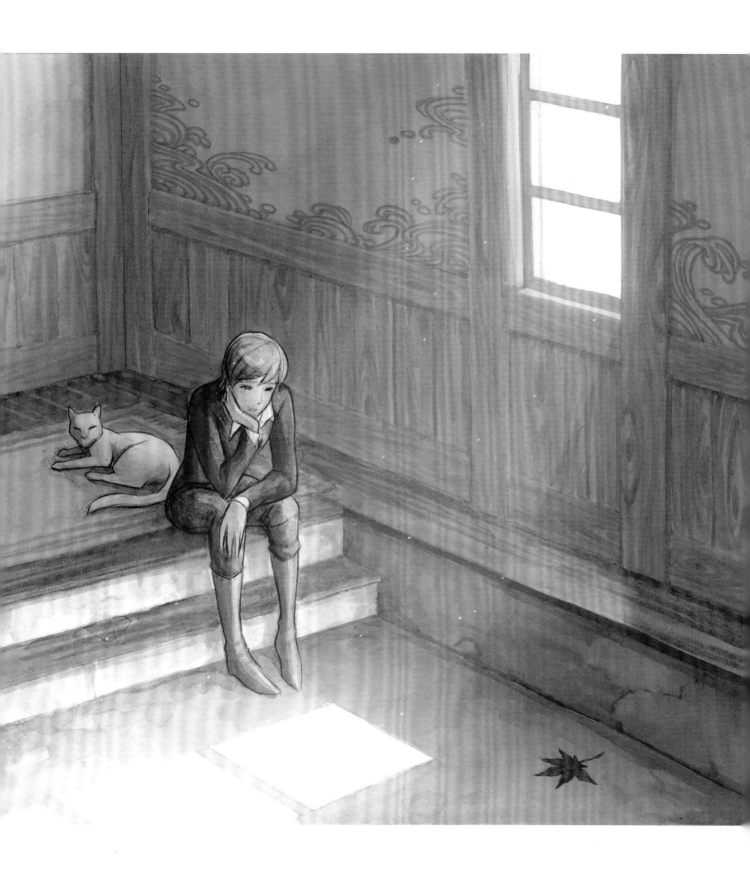

LOST IN THOUGHT

Among the many features that make Japanese homes different from those in the West is the *genkan*: an area of flooring between the front door and the rest of the house designed as a place for removing one's shoes. This area is almost always at a slightly lower elevation than the rest of the flooring, so as to maintain a clear separation between the grit and grime of the outside world and the clean, shoeless zone of the house's interior.

For this illustration, I wanted to use the genkan as a sort of metaphor for someone who is immobilized by indecision. The character is sitting where people normally either come or go, but she is doing neither. Judging by her pose, the viewer wonders if she ever will.

To complete this image, I turned to a wide variety of art supplies, doing my best to convey the specifics of this imaginary location: the concrete floor of the genkan (watercolor), the wave designs on the wall (marker), and the light pouring in through the window (computer). I'm a big believer in mixing various media like this, as I feel it can result in an interesting variety of surfaces within the illustration.

OPPOSITE
Lost in Thought
pencil, marker, colored pencil, watercolor, computer coloring; 9½ x 10¼ inches (24.1 x 26 cm).

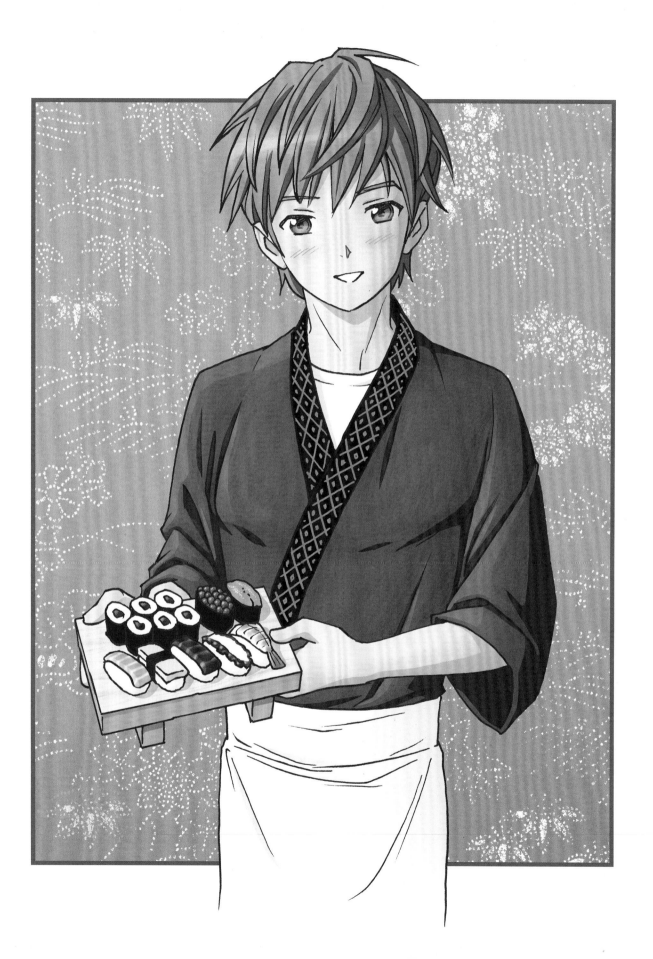

THE SUSHI CHEF

Having paid tribute to everyday meal items like ramen on page 43, I thought I'd devote at least one illustration to the more luxurious experience of having your meal prepared by a proper sushi chef.

Though I studied photos of actual sushi chefs in preparation, I decided to make the chef in my picture a classic manga character with oversized eyes and bright blue hair. The choice of blue was in some ways determined by the sushi itself: I wanted a cold color that would contrast with the warm reds and oranges of the food, thereby allowing the sushi to become a pleasing focal point in the image.

The natural slickness of computer coloring proved an excellent method for conveying the various shimmering surfaces of the sushi. It also made it easy for me to create the pattern on the sushi chef's collar, which was black in the original line art, but could be easily changed to pale blue in Photoshop.

SHOCKED CHIBI

I adapted this illustration from art created in my "How to Draw a Shocked Chibi" YouTube video. Of the three chibi illustrations in this chapter, this may be the one that gets closest to the heart of the chibi style. You really get the most out of chibis when you use them to convey human emotions in a humorous, exaggerated way.

Once again, you see a sound effect coming into this picture, written in *katakana*—one of the two phonetic writing systems used in the Japanese language. This time it's *gaaan*, an attempt at giving sound—fancifully enough—to the experience of shock itself.

Markers and colored pencils gave me the colors I needed, but the most valued player among the art supplies here was the white gouache. All those little white highlights throughout the illustration—on everything from the pieces of paper on the bulletin boards to the shiny effects on the spilled mug of coffee—brought much-needed contrast to the final image.

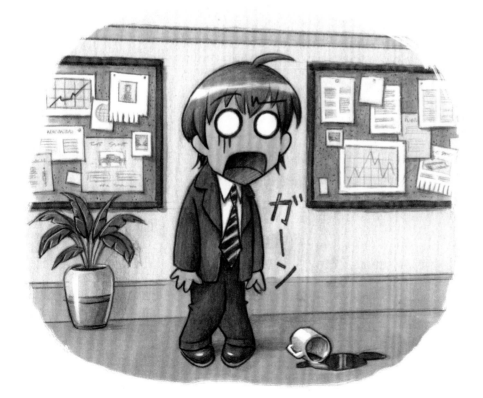

Shocked Chibi
pencil, marker, colored pencil,
white gouache;
5¾ x 7¾ inches (14.6 x 19.7 cm).

OPPOSITE
The Sushi Chef
pen and ink, computer coloring;
10½ x 6 inches (26.6 x 15.2 cm).

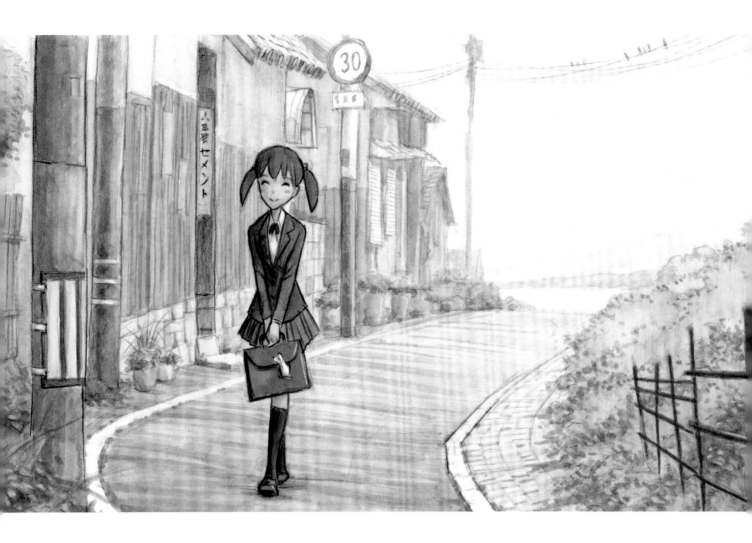

WALKING HOME

I patterned this illustration after art I created for a YouTube video, "How Artists Use Photo Reference." In the video, I showed how a photograph of a real road in Japan helped me to create an illustration that incorporated many of its details without being an exact copy.

This artwork is a good example of how I sometimes combine two different art supplies, using what might be called a "dual-layer" approach. I begin with a base layer that provides solid, uninterrupted color. In this case, I used watercolor, but in other illustrations I might opt for markers. The second layer is all about adding detail and tightening things up. For this type of work, I find colored pencils are ideal. They bring a level of precision that I think is difficult to achieve with watercolor alone.

Walking Home
pencil, watercolor, colored pencil,
computer coloring;
5½ x 9½ inches (14 x 24.1 cm).

Your Turn

Use a photograph to help you draw a certain location. Rather than copying every last detail, pick and choose the details you want to use, making the final image partially a place from your imagination.

MY LIFE IN JAPAN

The first time I set foot in Japan was in April 1991. I was twenty-five years old, heading to Morika, a smallish city in the chilly north, to begin an English teaching job. But let's be honest: I wasn't there to teach English. I was there to have an experience.

I had a sketch pad with me at all times. With every spare moment I had, I went around the city, drawing pictures and doing my best to learn how to speak Japanese. (Let's just say the drawing part came more naturally.)

My first encounters with manga were by way of restaurants, believe it or not. It's quite common for Japanese restaurants to keep shelves full of manga near their front doors, for customers to read while they wait to be seated. I remember flipping through these phone book–thick tomes, marveling at this style of drawing that was unlike anything I'd seen before. The hair. The eyes. The dynamic poses, leaping off the page. Trust me: in 1991, there was nothing like this back home.

I ended up staying in Japan for two years and two months. When I flew back home in 1993, that could well have been the end of my experience with Japan. But in 1997, in Michigan, I met a young Japanese woman named Miki, and by the end of the year I was down on one knee, asking her to marry me. Happily, she said yes. And in many ways, that was when my *real* Japan-related experience began.

Since then, we've visited Japan on average once every two years, often staying for as long as a month at a stretch. It was during these years that I got to know Japan in a deeper way, for Miki's parents really welcomed me into the family and made me feel a part of things every step of the way. It's no exaggeration to say that I have a kind of second life in Japan now. When I go there, I no longer feel that I'm in a foreign land. I feel like I'm at home.

With any luck, some of that familiarity has seeped into these illustrations. But let's be clear: to whatever degree these illustrations ring true as a portrait of Japan, I owe it all to Miki.

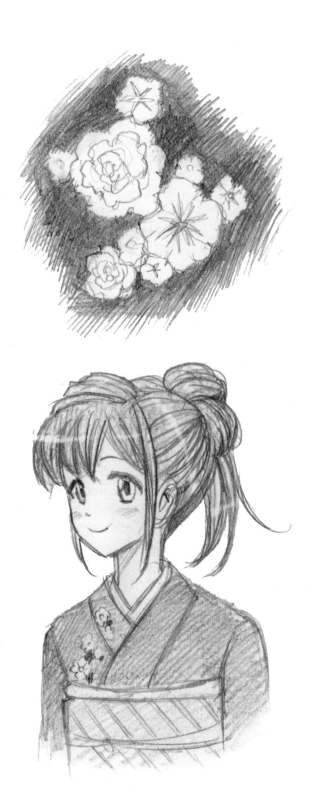

KIMONO

These days, most Japanese women don't often wear kimonos, and who can blame them? These traditional dresses take ages to put on, and are by all accounts pretty uncomfortable. However, they are still worn for special occasions, and what a treat it is to encounter someone wearing one as you're walking down a busy Japanese street. No type of clothing on earth is more beautiful.

With this picture, my goal was fairly straightforward: to present a manga-style character in a kimono, doing my best to capture the beauty of the various fabrics and patterns in illustrated form. Rather than begin with a standard piece of white paper, as I did with almost every other piece in this book, I opted for one that was a shade of brownish gray. This selection allowed the areas of white gouache to really "pop," standing out from the rest of the page due to the gouache's natural contrast against the color of the paper.

I found that rendering the kimono pattern demanded patience but was well worth the extra effort. As an artist, I never tire of seeing these wallpaper-like designs come together. It's a bit like completing a big jigsaw puzzle: all the more satisfying because it takes so long to do. Though I made an effort to balance the colors throughout the design, I was fairly spontaneous about deciding where the different colors would go. A bit of red here, and a bit of pink there: it was all a matter of instinct and following my muse.

OPPOSITE
Kimono
pen and ink, marker,
colored pencil, white gouache;
11 x 5 inches (27.9 x 12.7 cm).

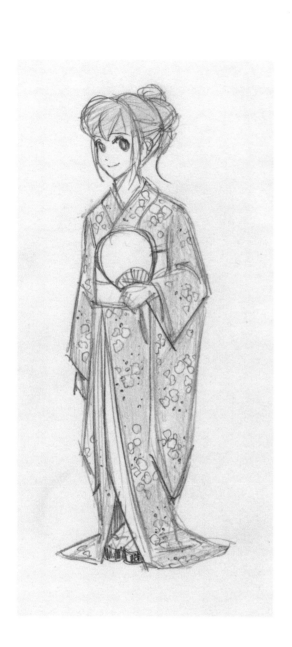

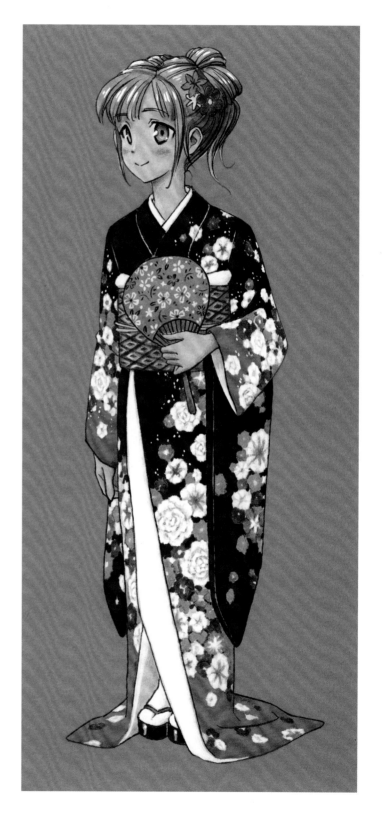

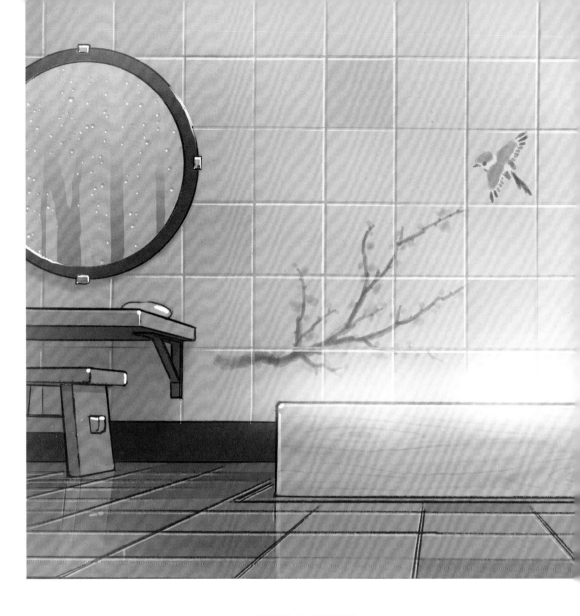

The Sento
colored pencil, computer coloring;
6½ x 13¾ inches (16.5 x 34.9 cm).

THE SENTO

The Japanese have special affection for soaking in a good, hot bath, and have put that love at the heart of their culture in a way that is unique among nations. Most widely known of these bathing options are the *onsen*, the natural hot springs that have been turned into spa resorts up and down the country. But such places are expensive. For a relaxing soak at a place around the corner, the Japanese will turn to their local *sento*: a public bath that simulates an onsen spa in many ways but is a bit more humble and considerably cheaper.

As I did with the *Red Umbrella* illustration (page 145), I deliberately chose an unusually horizontal picture shape here to convey peace and stability. I knew I wanted to portray a person relaxing in a bath, but I thought it

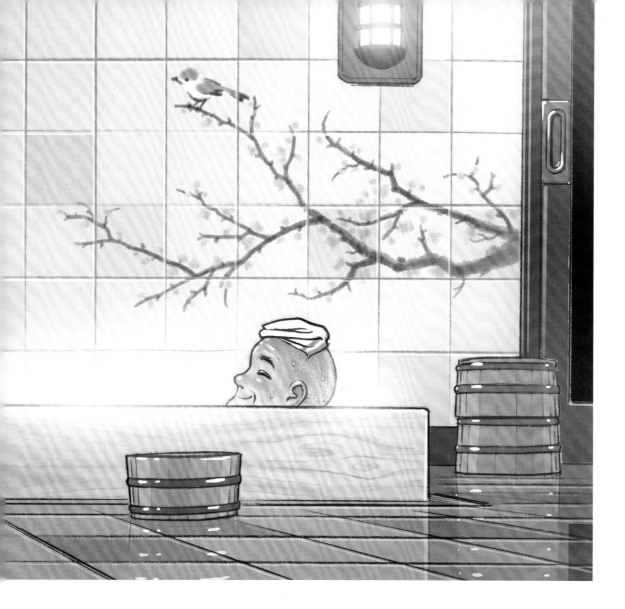

might be interesting to leave the visualization of the water up to the viewer's imagination. So I brought the point of view down to floor level and showed the bath only from the side. By forcing viewers to infer the presence of the water, I invite them to become my collaborators in completing the picture.

Knowing that steam would play an important role in the image, I did all the coloring work in Photoshop, where I could create areas of steam and mist with a few clicks of my mouse. Indeed, most of the effects in this illustration were greatly aided by the computer: everything from the reflections on the floor to the droplets of water on the mirror.

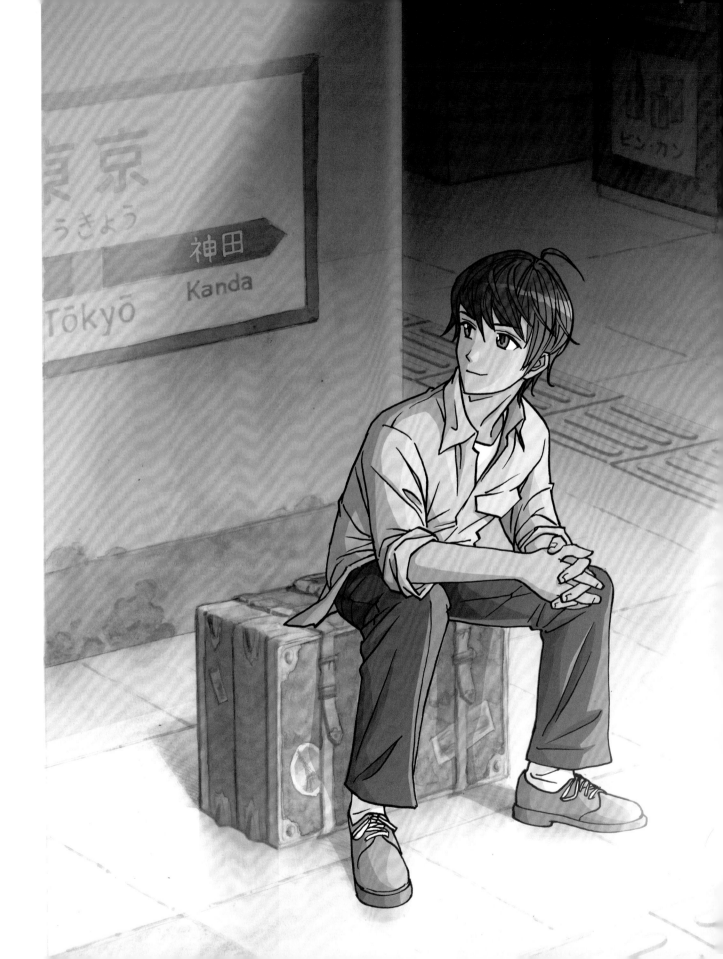

ON THE PLATFORM

People who travel can have vastly different experiences, depending on where they go and what they encounter along the way. But no matter what the itinerary, pretty much anyone who goes to Japan will find him- or herself in a train station at one point or another. If you live there and work there, you may well need to board trains on a daily basis. With that in mind, I wanted to have at least one of the pictures in this chapter relate to Japanese train travel in some way.

I got the idea of a young man, seated upon his suitcase on the platform, happily waiting for his journey to begin. To me, there's a certain magic about an anticipated journey: nothing has really happened yet, so anything is still possible. I also liked the slightly incongruous idea of an illustration about train travel in which trains aren't actually seen. It is only the details of the sign on the wall and the grooved yellow strips on the ground—installed to help the blind navigate the station with their canes—that identify this setting as a Japanese train station platform.

I used watercolor to render the suitcase and the rest of the background, but colored the young man entirely in Photoshop. This approach causes the figure to "float above" the background art a bit. It's a look that you can see in old animated movies, in which the backgrounds were often lushly painted, while the foreground figures were colored more simply so as to facilitate the animation process.

OPPOSITE
On the Platform
pencil, marker, colored pencil, white gouache;
12¼ x 9¼ inches (31.1 x 23.5 cm).

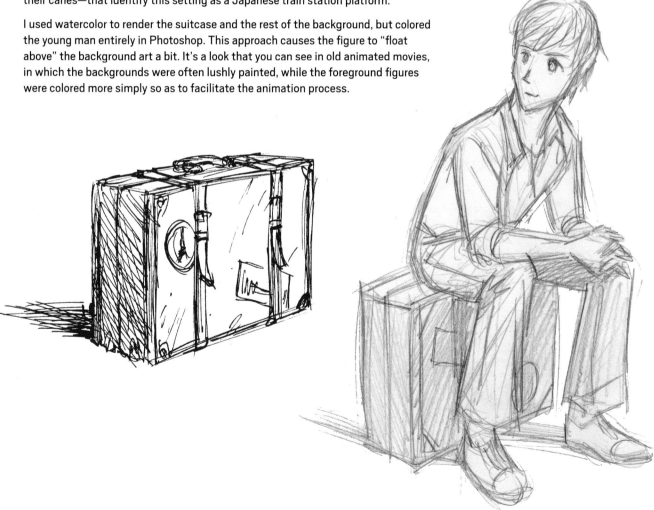

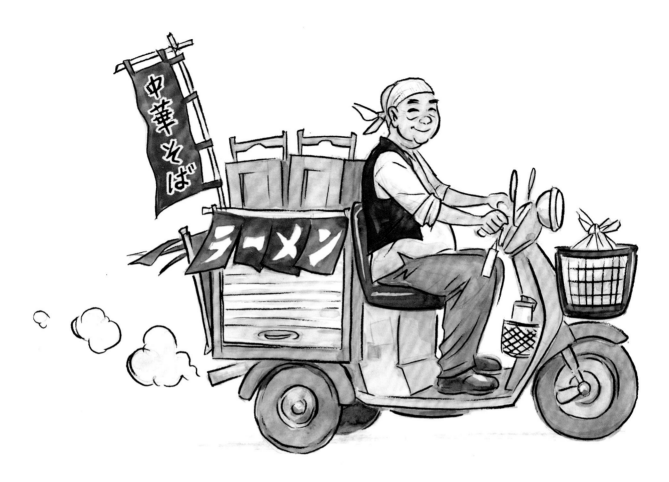

The Delivery Man
watercolor, pen and ink;
5½ x 8¼ inches (14 x 20.1 cm).

THE DELIVERY MAN

Having food delivered to one's home or office is commonplace all over the world, no doubt; however, in Japan it has a flavor all its own. That's partly because the food being delivered is far more likely to be a big bowl of ramen than a pizza or a bag of sandwiches. And while in America delivery is almost always via a car or van, in Japan the delivery vehicle of choice is a humble motor scooter of some kind.

For this illustration, I consulted photo reference, but soon decided to concoct my own imaginary ramen delivery scooter, one that was born of pure nostalgia. The boxes you see in the back are traditional wooden delivery boxes, within which you might find bowls of ramen on little shelves. You may recognize the banner on the back of the scooter: it's the same old-fashioned Japanese signage I included in my illustration of the taiyaki stand (page 46).

I chose a decidedly cartoony approach for this one to give the picture a cheerful, friendly feeling. Though the art materials I used were thoroughly old school—watercolor and ink— I did make use of the computer in one important respect. Rather than apply the ink directly to the illustration, I did it on a separate piece of paper, scanned it into the computer, and dropped the lines onto the art in Photoshop. This decision allowed for a level of absolute blackness in the line art that would have been difficult to achieve by traditional means.

THE MAILBOX

By now, you know that I am always on the lookout for old-fashioned things when I am in Japan. One such sight that consistently catches my eye is that of traditional Japanese cast-iron mailboxes.

As I set out to pay homage to such mailboxes, I thought that the best approach would be to use mostly traditional art supplies, thereby achieving a gentle, handcrafted look for my piece. I hit upon the idea of drawing a little boy dropping a letter in the box on his way to school. It seemed like something you might see in a children's picture book. And indeed I proceeded with the illustration as if it were just that.

Once I had the basics of the image sketched out in pencil, I went in with watercolor and tried to take things as far as I could with just that one medium. Adding a black outline to everything—even a really delicate one—seemed like the wrong approach to me. I wanted things to stay soft and slightly blurred, as if the viewer was seeing the scene through a mist of nostalgia.

The Mailbox
watercolor, colored pencil,
white gouache, computer coloring;
7¾ x 5½ inches (19.7 x 14 cm).

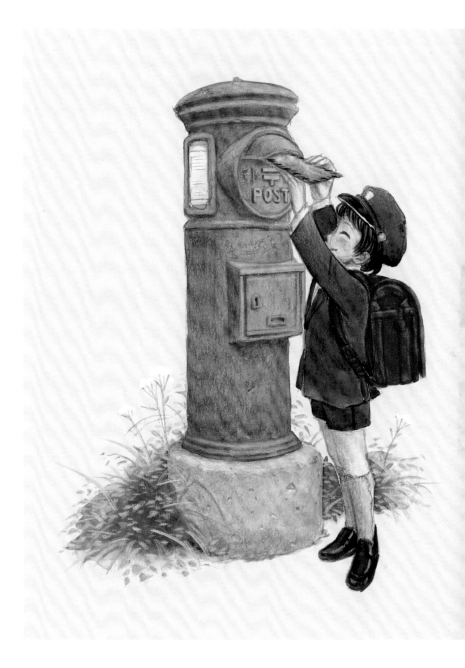

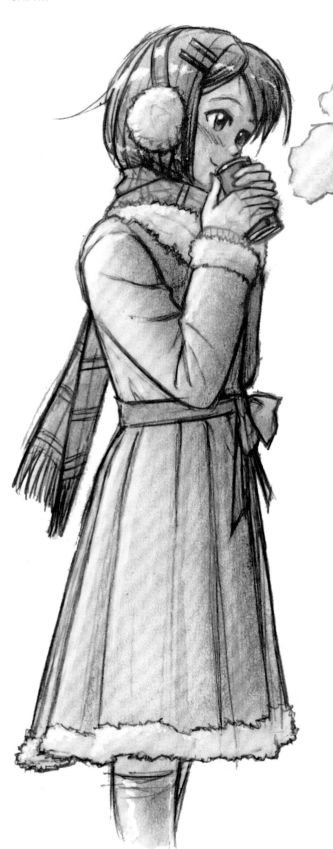

HOT CANNED COFFEE

Sometimes it's the simple things that you end up missing. When I lived in Japan, I used to get canned coffee from vending machines quite frequently. In the cold-weather months, the cans would come out piping hot: something I'd definitely never seen before in the USA. Half the pleasure of getting the coffee was in being able to warm your freezing fingers against the sides of the can.

My fond memories of those days certainly informed this illustration, which I did mostly with traditional drawing tools: marker, colored pencils, and gouache. As a final step, though, I scanned the piece into Photoshop and shifted the hues in two different directions: red in the area near the can, and blue everywhere else. The result is a picture that feels "warmer" at the top than it does at the bottom.

Hot Canned Coffee
pencil, marker, colored pencil,
pastel, white gouache;
9½ x 4½ inches (24.1 x 11.4 cm).

Your Turn

Do an illustration that makes use of the color blue to suggest cold, or red to suggest warmth. You could even combine the two into a single illustration, as I have done here. For a different effect, try using a blue-green hue as your cold color, or a yellow hue for your warm color.

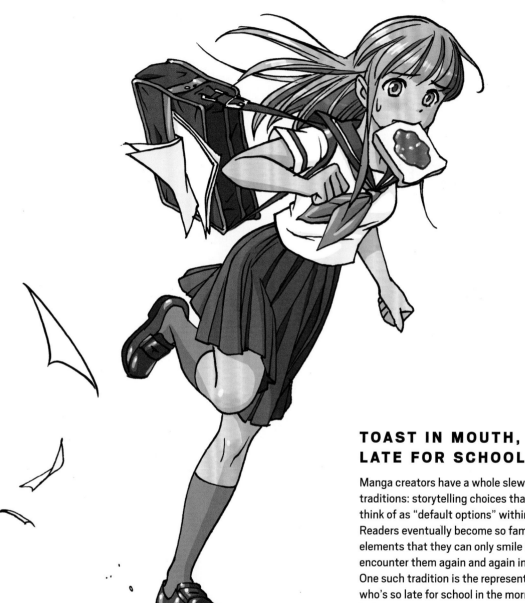

TOAST IN MOUTH, LATE FOR SCHOOL

Manga creators have a whole slew of funny little traditions: storytelling choices that you can almost think of as "default options" within the world of manga. Readers eventually become so familiar with these elements that they can only smile in recognition as they encounter them again and again in story after story. One such tradition is the representation of the student who's so late for school in the morning that he or she—lacking time for a sit-down breakfast—bounds out the front door with toast in his or her mouth.

I knew that I would have fun paying tribute to this time-tested manga cliché. Starting with pen and ink, I moved straight to Photoshop and applied all the colors digitally. Wanting to get the look of cel animation, I kept the colors quite flat. I allowed myself a fair amount of detail with the white highlights, though. From her shoes to her hair to the jam on the toast, these little flecks of white help give the image a shiny, sparkling quality.

Toast in Mouth, Late for School
pen and ink, computer coloring;
8 x 6¾ inches (20.3 x 17.1 cm).

OPPOSITE

Next to the Window, Second Seat from the Back of the Classroom pencil, pastel, colored pencil, computer coloring; 9½ x 7¾ inches (24.1 x 19.7 cm).

NEXT TO THE WINDOW, SECOND SEAT FROM THE BACK OF THE CLASSROOM

Another traditional manga concept is the idea that in any classroom scene, the main character's seat is invariably in the back of the room, next to the window. It's the perfect place to be: offering a nice view and enough distance from the teacher that the character can drift off into daydreams and not immediately be caught.

I consulted stills from anime films as well as photos of actual Japanese classrooms to come up with my setting. I've always been fond of depicting natural window lighting in an illustration (and I'm sure I'm not the only one; perhaps this is another reason for the manga world's "seat-by-the-window" trope). I spent extra time trying to capture the effect of sunlight striking the wall in the back of the classroom, using different colors to render the lit and unlit areas of the chalkboard.

Stylistically, this illustration is a sort of companion piece to the *On the Platform* picture earlier in this chapter (page 60). With both images, my goal was to pair a background that featured lush colors with a foreground figure colored in the minimalist manner of cel animation. This time I did the background with pastels—which are by their nature chalky and imprecise—so as to create even more contrast with the main character's supersmooth computer coloring. (Special thanks to my wife, Miki: she provided the handwriting I needed for the chalkboard.)

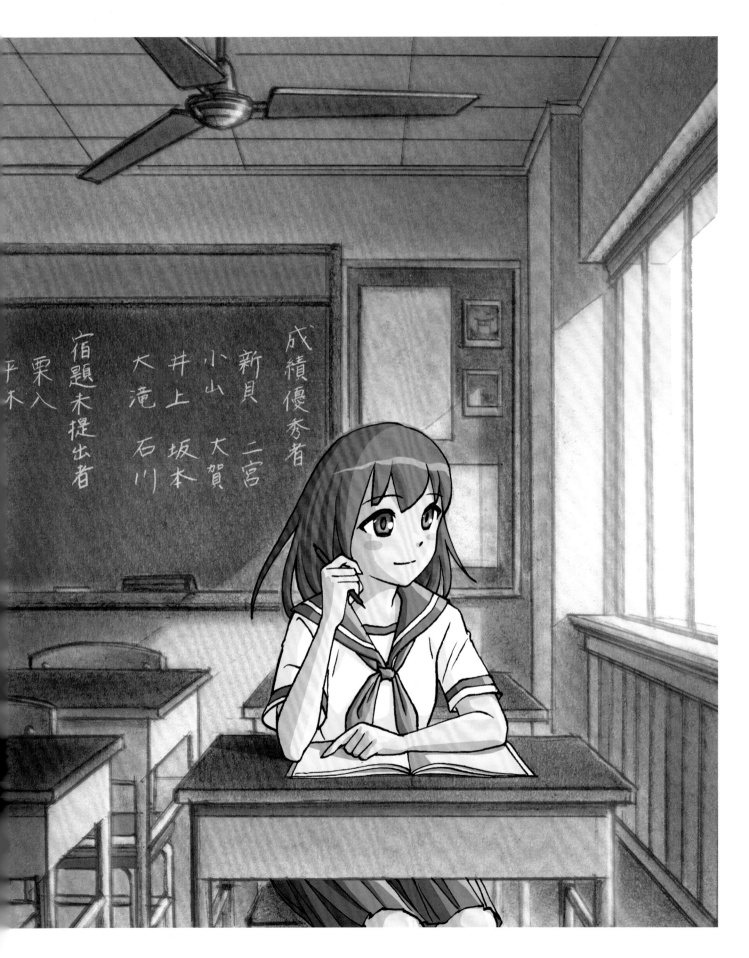

FICTION

3
SCIENCE FICTION

When it comes to sci-fi, I was definitely born at the right time. I was eleven years old when the original *Star Wars* came out. And let's be clear: *Star Wars* was the biggest of big deals. But a few months later, there was also *Close Encounters of the Third Kind*, and then *Alien*, and then *Blade Runner*. My childhood friends and I knew that these were awesome films even then, but looking back from the perspective of 2017, it's like we were waltzing through a golden age of sci-fi cinema.

Sift through my drawings from that time, and you'll find page after page of rocket ship drawings, most of them specifically inspired by *Star Wars* or *Close Encounters*. I was particularly fascinated by the details of their ships. That Star Destroyer that came over the top of the screen right at the start of what we're now calling *Episode IV* . . . well, I felt like I could look at that thing forever. Ditto for the mothership at the end of *Close Encounters*. I may not have realized it at the time, but this stuff burned its way into my brain, destined to reemerge in my own work years later.

In adulthood, I watched Katsuhiro Otomo's seminal animated film, *Akira*, and began to see how the Japanese had put an entirely new spin on science fiction. Here was a fresh approach to sci-fi, with aspects of Japanese culture woven into the fabric of the story, and a highly personal viewpoint that was as artistic as it was uncompromising. Around the time that I was beginning work on my *Brody's Ghost* series of graphic novels for Dark Horse Comics, I borrowed Otomo's *Akira* manga series from a local library. It proved a decisive influence, encouraging me to have my story unfold in a dystopian urban setting.

Fast-forward to 2016, when I'm deciding what types of artwork to create for this book: it's no surprise that devoting a chapter to sci-fi images was one of the first things that popped into my brain. It's like I've been practicing for it since 1977. And while you won't see characters from *Star Wars* or *Akira* in the pages ahead, you'll definitely see the influence of both.

There are robots and rockets, space colonies and dystopian landscapes, and enough futuristic vehicles to fill an intergalactic starship hangar. (And yes, there is also an intergalactic starship hangar, see page 85.) The featured illustration styles range from rough and loose to sleek and seemingly untouched by human hands. And though there's a fair amount of seriousness, there's plenty of humor as well.

So please turn the page and have a look at what this eleven-year-old *Star Wars* fan went on to create after he'd grown up into a married-with-kids *Star Wars* fan. Every one of these illustrations seeks to fuse sci-fi with manga, showing that—in my opinion, at least—the two were really made for each other.

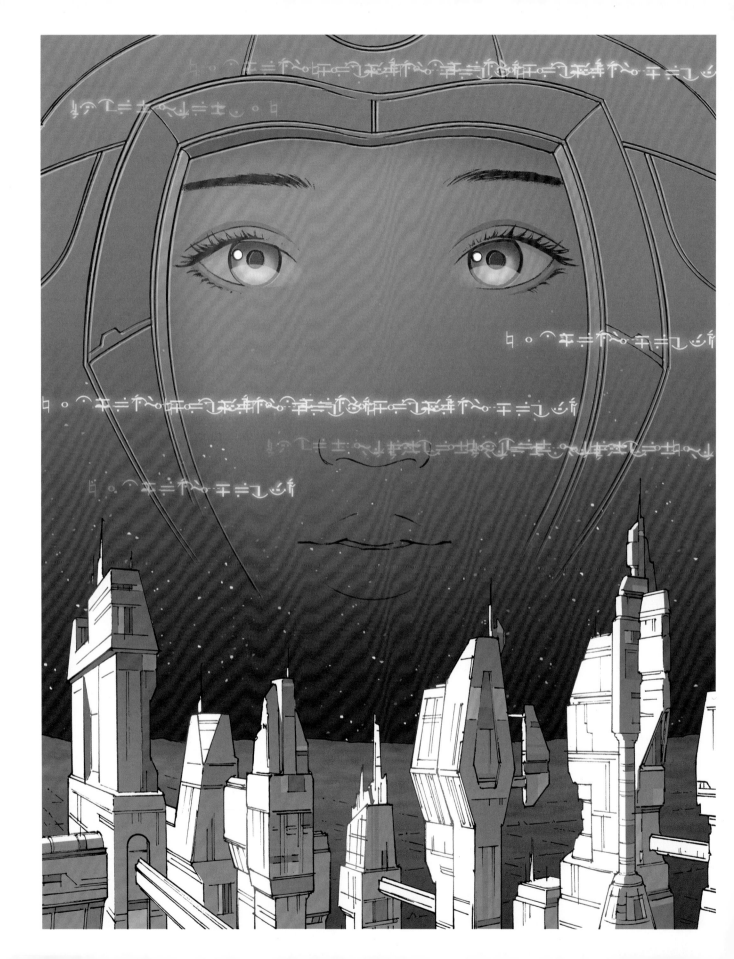

AT GALAXY'S EDGE

When I was a kid, most of the sci-fi artwork I saw came in the form of book cover illustrations. In many cases, the artists of those covers were entrusted with creating the only piece of art that would ever be made for the stories within, and you could tell that they took their jobs seriously. Whether they presented an alien landscape or a massive spinning space station, those artists had to create illustrations that were more than just pretty—they needed to transport readers to other worlds.

Having never had the opportunity to illustrate a sci-fi book cover, I figured I'd devote at least one illustration to seeing how I would handle such a job. I imagined a story set in a space colony way out on the edge of the galaxy, and a main character sent there on a dangerous mission. The cover's job would be to introduce readers to both the main character and the space colony setting.

I began my illustration with pencil, but wanted this image to have nice clean lines, so I inked it, taking care to lay down almost every line with a single confident stroke of the pen. I did everything else in Photoshop. I chose to let viewers see through the face and into the starry sky beyond, coloring in just the eyes, which created a slightly spooky effect. But sometimes spooky is just what you need.

OPPOSITE
At Galaxy's Edge
pen and ink, computer coloring;
14 x 11 inches (35.5 x 27.9 cm).

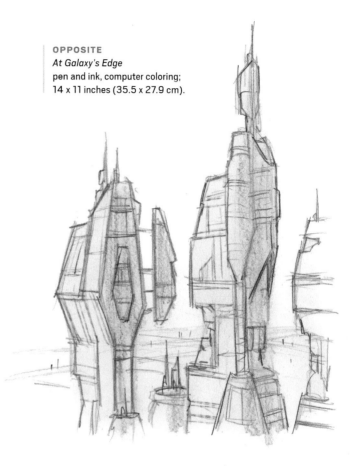

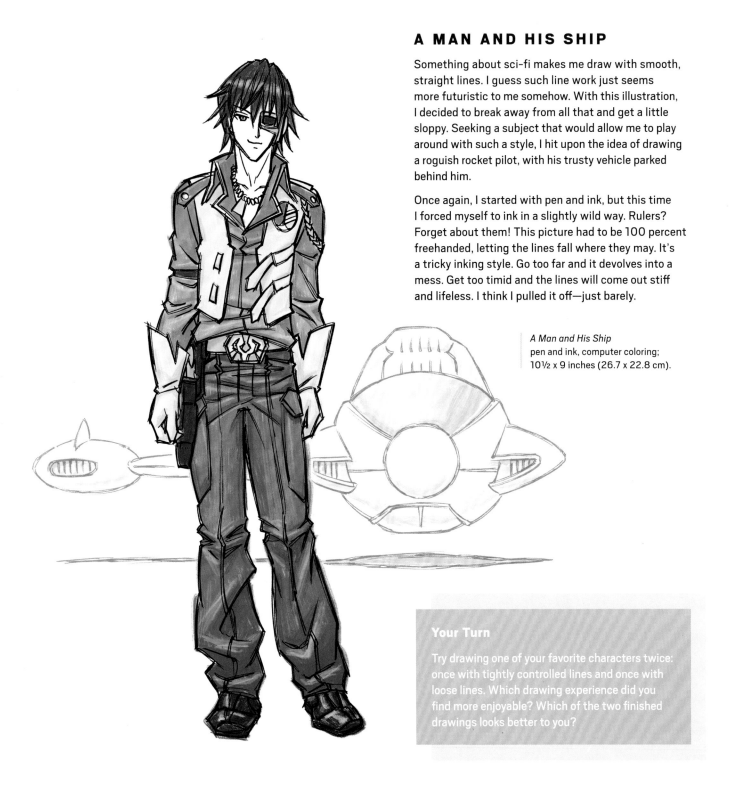

A MAN AND HIS SHIP

Something about sci-fi makes me draw with smooth, straight lines. I guess such line work just seems more futuristic to me somehow. With this illustration, I decided to break away from all that and get a little sloppy. Seeking a subject that would allow me to play around with such a style, I hit upon the idea of drawing a roguish rocket pilot, with his trusty vehicle parked behind him.

Once again, I started with pen and ink, but this time I forced myself to ink in a slightly wild way. Rulers? Forget about them! This picture had to be 100 percent freehanded, letting the lines fall where they may. It's a tricky inking style. Go too far and it devolves into a mess. Get too timid and the lines will come out stiff and lifeless. I think I pulled it off—just barely.

A Man and His Ship
pen and ink, computer coloring;
10½ x 9 inches (26.7 x 22.8 cm).

Your Turn

Try drawing one of your favorite characters twice: once with tightly controlled lines and once with loose lines. Which drawing experience did you find more enjoyable? Which of the two finished drawings looks better to you?

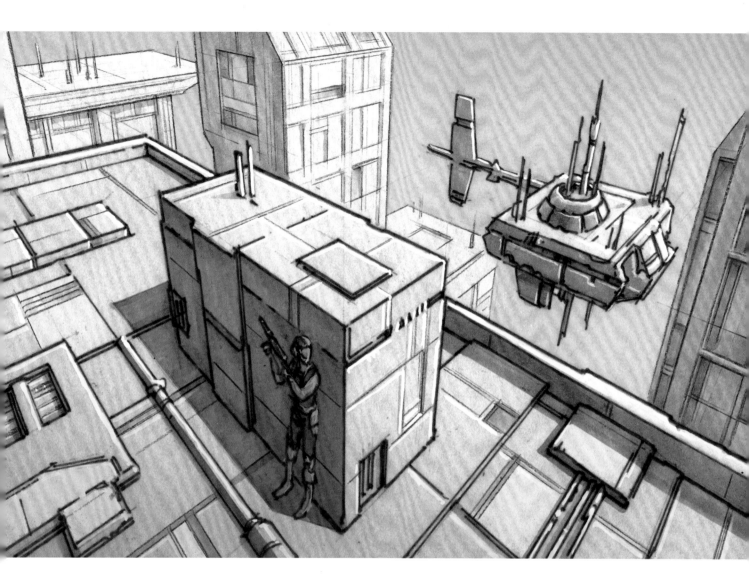

THE DRONE

This illustration is the first of several in this chapter that I adapted from art originally created for my YouTube videos. I find that sci-fi settings are great for teaching perspective drawing. Cube-like structures are much easier to draw in perspective than rounded or irregular ones, and you can create futuristic environments from cubes very easily. Indeed, a setting much like the one you see here was the end result of a video I made called "How to Draw Backgrounds: Three-Point Perspective."

My original drawing, in black and white, was rather bare. In revisiting the image, I decided to create more depth, adding several buildings in the background as well as considerably more detail throughout the entire image. I also tinted the art a purplish blue in Photoshop to give the picture a touch more color.

Though I didn't originally think of this image as anything other than a "demo drawing," I now see a slightly mysterious narrative aspect to it. Who is that guy with the rifle? What's the connection between him and the drone? You can find stories everywhere, it seems—even tucked away in videos about three-point perspective.

The Drone
pencil, pen and ink, marker, white gouache, computer coloring;
6¼ x 9¾ inches (15.9 x 24.7 cm).

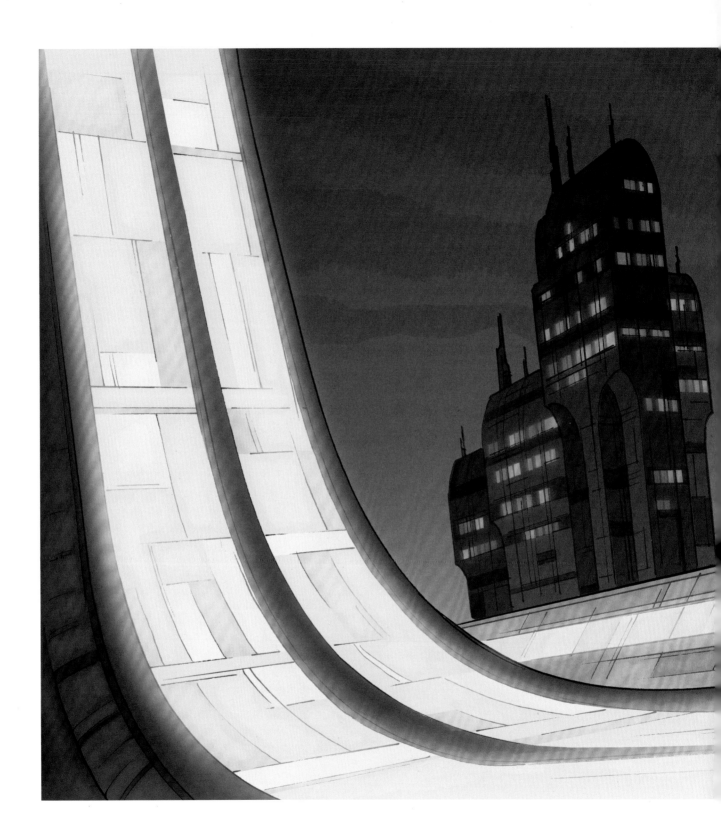

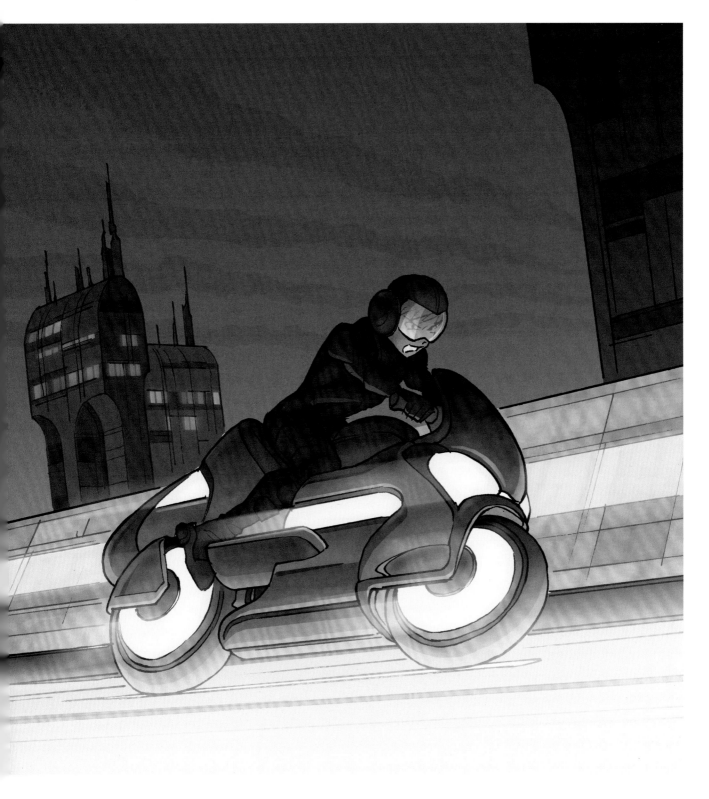

200 mph
pen and ink, computer coloring;
7 x 14 inches (17.8 x 35.5 cm).

200 MPH

Start talking about the greatest manga series of all time, and Katsuhiro Otomo's *Akira* has got to be part of your conversation. Certainly no other manga has ever surpassed its artwork, in my opinion. And while the illustration on the previous spread isn't necessarily meant to emulate Otomo's style, it owes a lot to *Akira*'s world of dark cityscapes and futuristic motorcycles.

The most fanciful aspect of the picture is its glowing green road, which seems to include both horizontal and vertical segments. Oddly enough, that wasn't a part of the original drawing. I thought I'd just show my sci-fi motorcyclist racing along a fairly conventional strip of highway; however, it felt like something was missing. My imagination told the laws of gravity to buzz off, and I ended up with the image you see here.

Just as with *At Galaxy's Edge* (page 73), I started with pen and ink and immediately moved to computer coloring. This piece takes advantage of one of Photoshop's *blur filters*, settings that allow you make parts of your artwork appear foggy and indistinct. I applied a motion blur to the lights of the motorcycle, causing them to fade off to the left in a way that suggests incredible speed.

Your Turn

Do an illustration that portrays a character moving at great speed. See if you can add to the sense of urgency by way of the character's facial expression, or by the addition of a dramatic location.

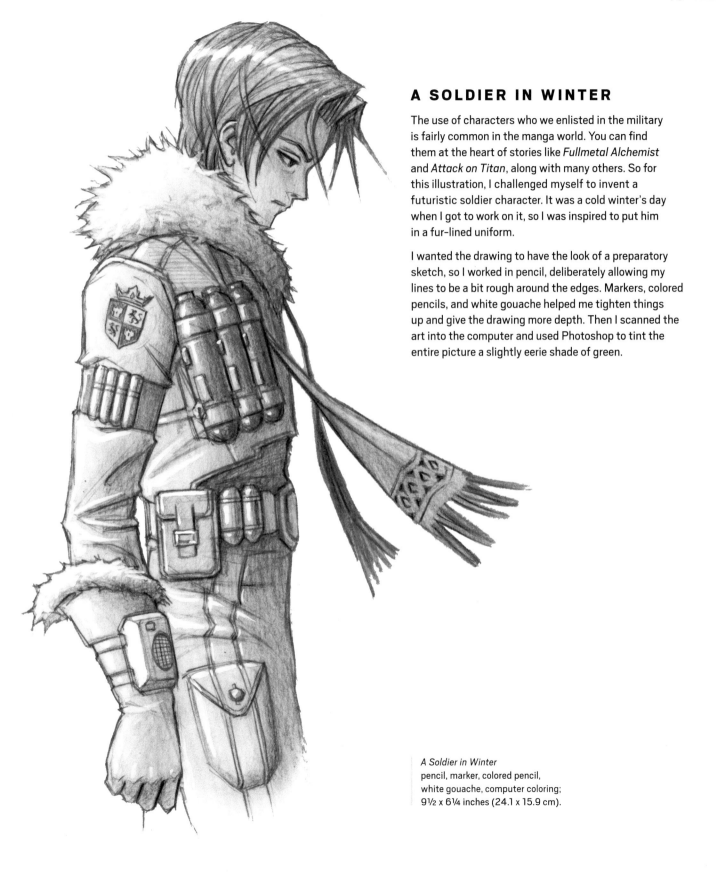

A SOLDIER IN WINTER

The use of characters who we enlisted in the military is fairly common in the manga world. You can find them at the heart of stories like *Fullmetal Alchemist* and *Attack on Titan*, along with many others. So for this illustration, I challenged myself to invent a futuristic soldier character. It was a cold winter's day when I got to work on it, so I was inspired to put him in a fur-lined uniform.

I wanted the drawing to have the look of a preparatory sketch, so I worked in pencil, deliberately allowing my lines to be a bit rough around the edges. Markers, colored pencils, and white gouache helped me tighten things up and give the drawing more depth. Then I scanned the art into the computer and used Photoshop to tint the entire picture a slightly eerie shade of green.

A Soldier in Winter
pencil, marker, colored pencil,
white gouache, computer coloring;
9½ x 6¼ inches (24.1 x 15.9 cm).

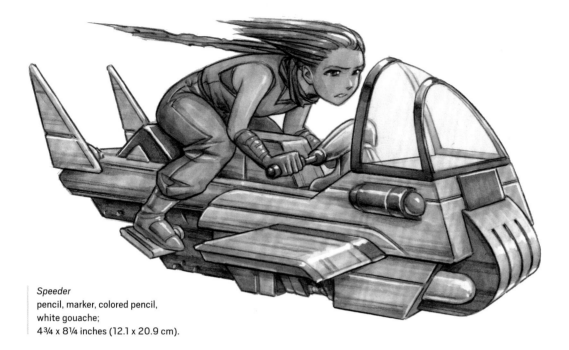

Speeder
pencil, marker, colored pencil,
white gouache;
4¾ x 8¼ inches (12.1 x 20.9 cm).

SPEEDER

Coming up with sci-fi characters is a pleasure, but the real fun begins when you start designing their vehicles. Sci-fi stories allow you to visualize any mode of transportation your brain can cook up—whether it's a massive spaceship or a tiny little scooter.

For this illustration, I imagined a manga character zooming from one place to another in her own one-seater vehicle—a tough little rocket that seems built for speed. I could have gone for something more brightly colored, but I liked the idea of a no-nonsense piece of hardware: all sharp angles and brushed steel.

I relied mostly on markers for the coloring, with just a bit of colored pencil shading around the edges. Touches of white gouache helped me create the illusion of a shiny surface. I couldn't say where this young woman is headed, but one thing's for sure: she'll be there before you know it.

LAST MAN STANDING

Here's another piece with origins in my perspective video drawings. This one began life as a simple demonstration of *one-point perspective*, a method of drawing environments and objects in which many of the lines in the image recede to a single point in the distance. Once again, though, a narrative element emerged from within all those straight lines. The solitary figure walking along a dried-up canal may not be the last man on earth, but the picture certainly doesn't offer much evidence to the contrary.

I lightly inked this illustration, leaving the watercolors to be the real foundation of the art. I went in with the watercolor brush again and again, each time with a slightly different color, trying to build up a complex, distressed finish on all the various surfaces.

Sometimes I think it's not so much that we artists genuinely believe the world's future will be gritty and decaying like the one in this picture—we just love illustrating all those weather-beaten surfaces!

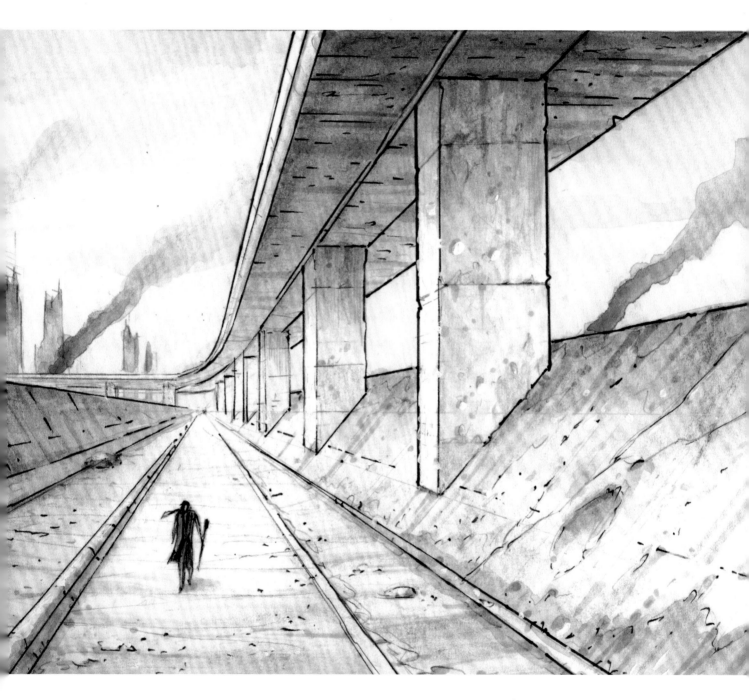

Last Man Standing
pencil, watercolor, colored pencil,
pen and ink;
5¼ x 7¾ inches (13.3 x 19.7 cm).

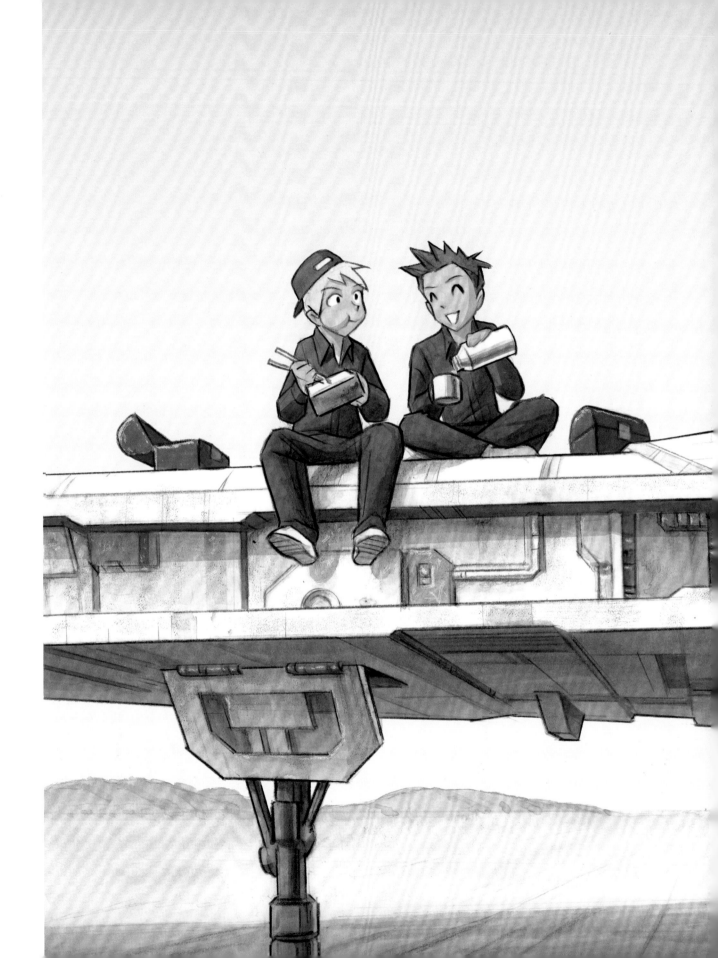

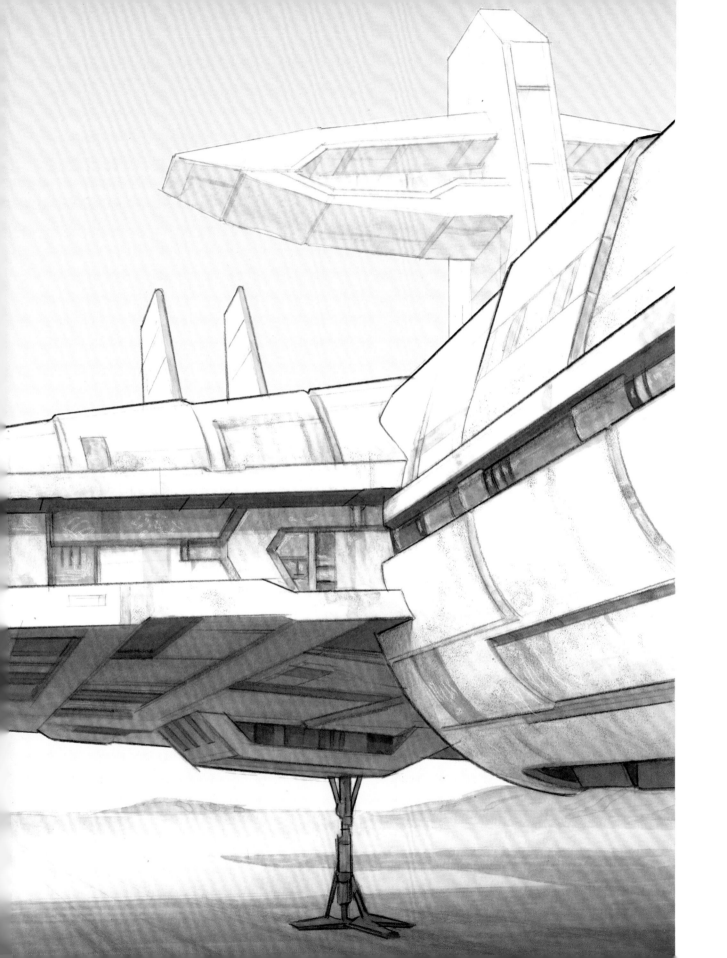

LUNCH BREAK

If I have any problem with science fiction, it's that it sometimes takes itself a little too seriously. With this illustration, I wanted to work with a futuristic setting and use it to portray something more lighthearted: two rocket maintenance guys on their lunch break. I liked the contrast between this huge impressive starship and the ordinary working stiffs who keep it running properly.

Once I got the composition down in pencil, I went in with watercolors and markers to render the surface of the ship. When rendering the tail in the distance, I left all the colors quite pale and washed out, so as to have that part of the ship appear farther away. Color also plays a key role in drawing the viewer's eye toward the two figures: all the colors are much brighter in this area of the drawing.

PREVIOUS SPREAD
Lunch Break
pencil, watercolor, marker,
colored pencil, computer coloring;
11 x 14 inches (27.9 x 35.5 cm).

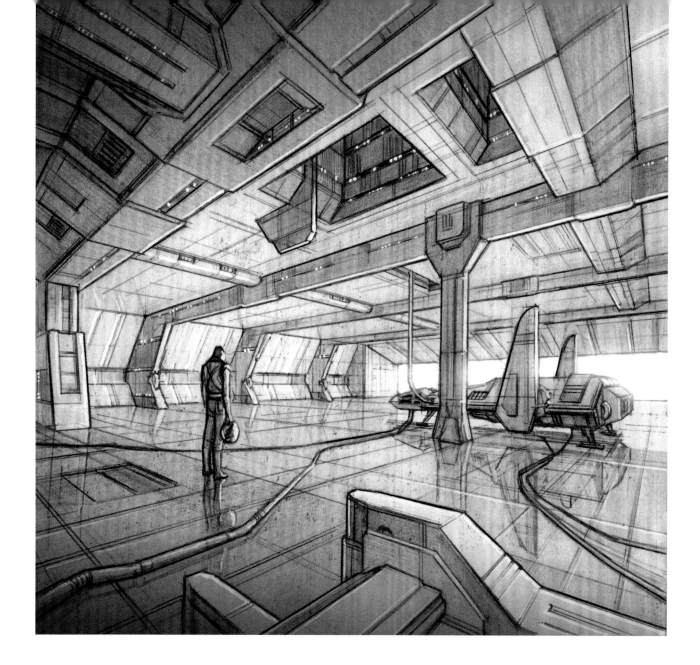

THE HANGAR

This image also began its life in one of my perspective videos on YouTube "How to Draw Interior Spaces," but this time I reinvented the illustration in a pretty fundamental way. The original picture showed two guys with *Star Wars*–style lightsabers, standing off against each other prior to a duel.

I expanded the image area on both the top and the bottom, got rid of one of the duelists, and replaced him with a small spaceship. I now saw my subject as a pilot waiting as his ship got fueled up for a big mission.

My use of Photoshop was limited. However, one little trick with that program proved crucial: blurring the white light pouring in from outside the hangar entrance. As in my motorcyclist illustration, *200 mph* (pages 76–77), I did it all with just a few clicks of my mouse. But boy, did those clicks make a big difference!

The Hangar
pencil, colored pencil, white gouache, computer coloring;
7¾ x 8 inches (19.7 x 20.3 cm).

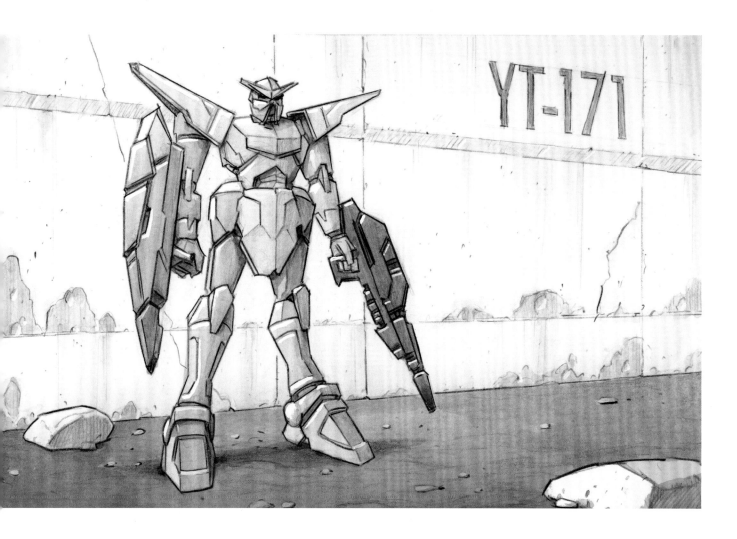

MECHA SENTRY

Mecha Sentry
pencil, watercolor, colored pencil,
white gouache, computer coloring;
5¼ x 8 inches (13.3 x 20.3 cm).

Part of what makes manga popular is the Japanese sense of style. Cartoon characters have been around for decades, but once illustrators in Japan began drawing them in their own distinctive way, the rest of the world had to take note. Nowhere is this clearer than in the realm of sci-fi robots. A few decades ago the Japanese devised a type of design that had simply never been seen before called *mecha*. These sleek, futuristic-looking robots featured shapes and proportions born of a unique Japanese aesthetic: clean lines and sharp angles that suggested style was just as important as function.

For this illustration, I studied mecha carefully—both in illustrations and toys—to make sure I understood the proportions as well as the types of shapes used for the individual components of these characters. Rather than make my mecha character shiny and new, I tried giving him a slightly weathered look. I wanted the robot to be the focus of the illustration, so I kept the background spare and only moderately detailed. It's a method you can use any time you want the viewer's eye to stay focused on the foreground.

SCI-FI ART THROUGHOUT MY CAREER

Science fiction has been more or less a constant throughout my career as a writer and artist. My first published comic book series, *Akiko*, was about a little girl who goes to another planet and has a series of adventures there. I always described the basic concept as "*The Wizard of Oz* meets *Star Wars*," and that's still not a bad way of summing it up. The series was rooted in classic children's stories, but with robots and rocket ships thrown into the mix.

Late in *Akiko*'s fifty-three-issue run, I did a story called "The Battle of Boach's Keep," in which the balance leaned decidedly toward the sci-fi side of things. There were giant starships, hologram messengers, and—as the title promised—explosions aplenty as tensions on a distant desert planet built toward an all-out military confrontation. The artwork required for that story forced me to take myself a little more seriously as a science fiction illustrator. I wanted longtime *Akiko* readers to look at those pages and say, "We're not in Oz anymore."

With the *Miki Falls* series, I turned away from science fiction for a while, devoting my energy instead to learning how to draw in a manga style.

When it came time to create *Brody's Ghost*, my series of six graphic novels for Dark Horse Comics, I realized I had the opportunity to combine the science fiction work of my early career with the manga-infused style of my more recent work.

At the heart of The series's story was a paranormal murder mystery of sorts, but I decided early on to move the setting from the present day to a dystopian future. Like so many before me, I turned to Ridley Scott's film *Blade Runner* as a source of inspiration, as well as the aforementioned epic manga series *Akira* (see page 70). I wanted people reading *Brody's Ghost* to feel like they were in a specific and believable place: a world that had a number of futuristic aspects to it, but otherwise had quite a lot in common with our own. The result was my most ambitious attempt yet at creating a believable sci-fi environment for a story.

Now that I've reached the end of the *Brody's Ghost* series, it's probably time to take another break from science fiction for my next project. But if the past is any predictor of the future, it won't be long before the siren's call of sci-fi has me spinning another yarn about robots and rocket ships.

RIDER

Just because your story is set within the genre of science fiction doesn't mean you have to make everything in it appear futuristic. Some sci-fi creators choose to focus more on fantasy elements and to reduce the importance of high-tech gizmos within the universe they've created. I wanted to try such an illustration: a picture where the futuristic aspects are kept in the background.

I had fun inventing the details of this guy's world: his clothing, his flag, his stoic reptilian steed. To make sure I got his pose and posture right, I consulted photos of people on horseback. One of the biggest misconceptions that young artists have about professional illustrators is that we draw everything from memory. Not me. I never hesitate to use reference photos in order to get the fundamentals of my pictures right.

I decided to go fairly detailed with the line work, but to keep the coloring a little minimalistic. The character's skin, for example, is composed of just two different shades of the same color, and that is true of almost everything in the whole image.

OPPOSITE
Rider
pen and ink, computer coloring;
13 x 10 inches (33 x 25.4 cm).

Your Turn

Do a drawing of a character riding some sort of imaginary animal. Design clothing and riding gear that fits together as part of a single alien culture. Think about what the animal is for: transportation? hunting? something else?

Night Train
pencil, computer coloring;
4¾ x 7½ inches (12.1 x 19 cm).

NIGHT TRAIN

This fourth and final perspective illustration from a YouTube video called "How to Use One-Point Perspective," makes an interesting contrast with the first one, *Last Man Standing* (page 81). While one shows a panoramic exterior scene and the other a smaller scale interior space, I built both on a near-identical system of one-point perspective. It just goes to show the wide variety of locations you can illustrate once you know the basics of perspective drawing.

The dystopian setting is reminiscent of environments in my *Brody's Ghost* graphic novels, which were themselves heavily inspired by manga series like Otomo's *Akira* and Yukito Kishiro's *Battle Angel Alita*.

I created the original illustration as a monochromatic pencil illustration and then enhanced it with a bit of gouache. This time, I decided to do all the coloring in Photoshop. Using a stylus and a Wacom tablet, I worked into the surfaces in the manner of a watercolorist, building up layers and striving to introduce subtle variations in color from one tiny area to the next.

MAID OF METAL

Manga faces are pretty easy to recognize when you see them. The large eyes, the placement of the nose and mouth, and even the shape of the head all help set these characters apart from ones seen in Western culture. With this illustration, I wanted to see if I could apply these distinctive facial proportions to a robot character—one that is humanoid to a degree, but clearly a machine, not a person.

I did my line art in pen and ink, but immediately scanned the image into Photoshop afterward and did everything else digitally. To give the illustration a greater feeling of depth, I introduced very slight color differences between one "plate" and another on the surface of the skin. I made the eyes stand out by using substantially darker colors for them. The lighting in the illustration seems to come from at least two sources: the primary one being from the left, plus a yellowish bit of backlighting coming from the right. That is a trick you can use to make shiny objects look even shinier, since the viewer's eye tends to read the extra highlights as indicative of a superreflective surface.

Maid of Metal
pen and ink, computer coloring;
8 x 3¼ inches (20.3 x 8.25 cm).

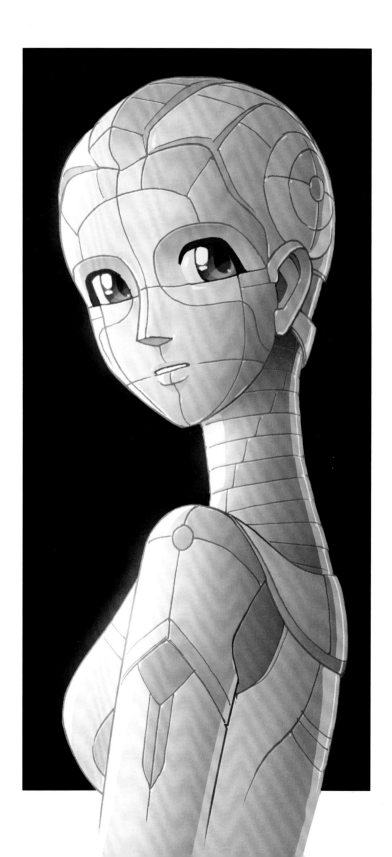

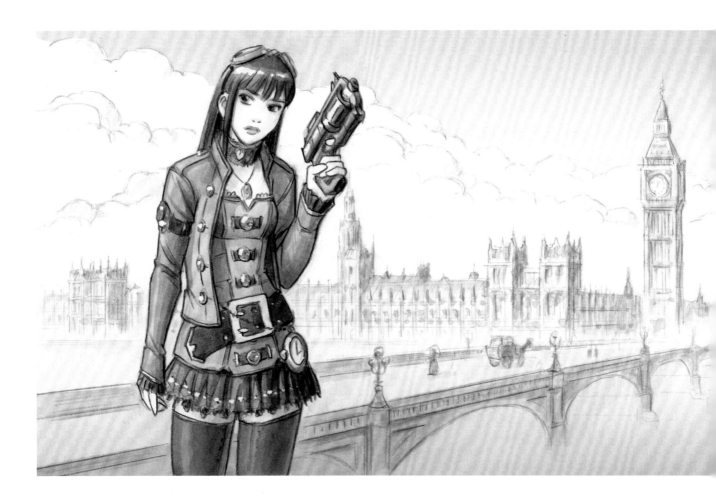

London Steampunk
pencil, watercolor, marker,
colored pencil, white gouache,
computer coloring;
5¼ x 8¾ inches (13.3 x 22.2 cm).

LONDON STEAMPUNK

One of the more interesting subgenres of science fiction to come along in recent decades is that of *steampunk*. Steampunk takes the futuristic vibe of sci-fi and transplants it into the nineteenth century, imagining an alternative history of fantastical technologies powered by steam. The Japanese have made important contributions to the subgenre, such as Katsuhiro Otomo's animated feature, *Steamboy*.

For this picture, I wanted to give steampunk my own manga-style spin. My main sources of reference were photos of cosplayers. (For more on cosplay, see page 134.) Truly, no one knows this genre better than the people who make their own steampunk clothing; their attention to detail is astounding.

This picture is unusual among the others in this book insofar as it features quite a lot of ordinary graphite pencil as final line work. The backdrop of Victorian London is essentially a pencil drawing with a bit of watercolor added, and nothing else. The lightness of the pencil lines helps that part of the drawing drop back into the distance, allowing the figure—which I outlined with a black colored pencil—to pop out into the foreground.

THE JUNGLE GYM

When I decided to place my *Brody's Ghost* graphic novels in a dystopian urban setting, it meant I had to draw cityscapes for the entire seven-year run of the series. As a result, I created my most fully realized imaginary location for a comic book story ever.

For this illustration, I thought I'd go back to Brody's hometown one last time, depicting it much as I did in the actual graphic novels. My idea was to present a shabby-looking alleyway, grim and gritty in all respects, except for one: the presence of a children's jungle gym.

I began the illustration with pen and ink, along with a few touches of gray marker. After that, I scanned the art into Photoshop and added gray tones, as well as a couple of digital effects: beams of sunlight and a flock of birds. I drew the birds with my Wacom stylus and pad, moving each bird around until I had just the formation I wanted.

The Jungle Gym
pencil, marker, pen and ink,
computer coloring;
10½ x 4¾ inches (26.7 x 10.8 cm).

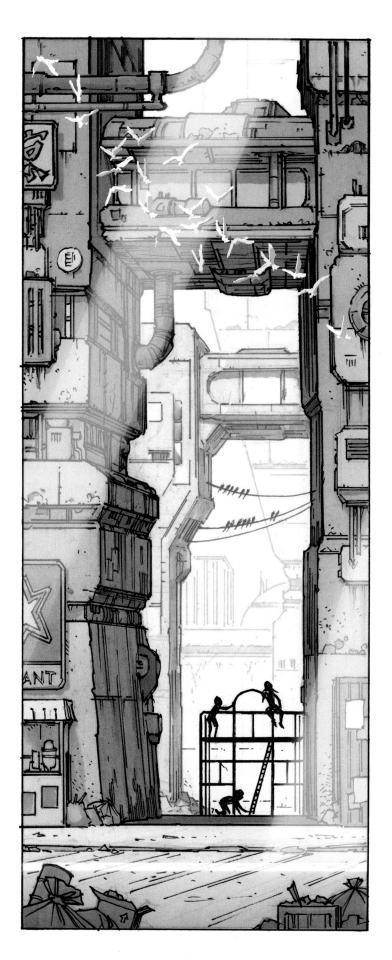

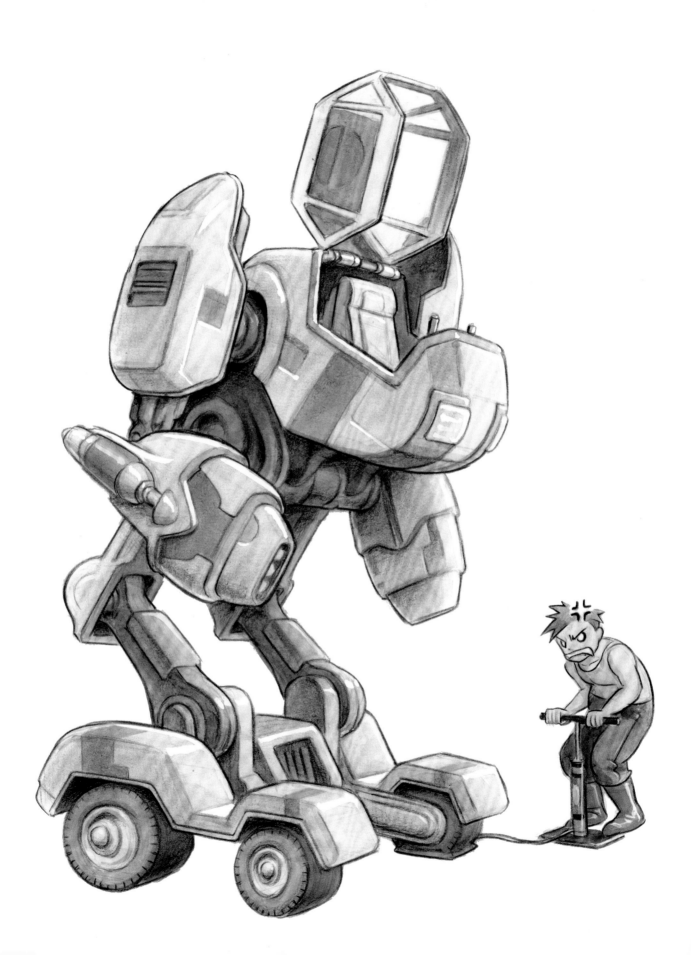

FLAT TIRE

With my *Lunch Break* illustration on pages 82–83, I tried looking at the lighter side of sci-fi, but with this picture I went for straight-up comedy. My idea was to take a high-tech "robo-vehicle" and bring it down a notch by showing it defeated by the everyday nuisance of a flat tire. It's all in keeping with the manga spirit of making things fun and finding humor in unexpected places.

The decision to make the picture taller than it is wide was actually a major factor in executing the joke: I wanted the viewer's eye to start at the top, with the serious part of the drawing, before moving down to the "punchline" in the lower right-hand corner.

Watercolor is a key player in this one, though markers helped a lot in establishing the shadowy areas. Little dabs of white gouache throughout the image help to convey the various surfaces of the vehicle, giving them a semigloss finish.

OPPOSITE
Flat Tire
watercolor, marker, colored pencil, white gouache;
10 x 7¾ inches (25.4 x 19.7 cm).

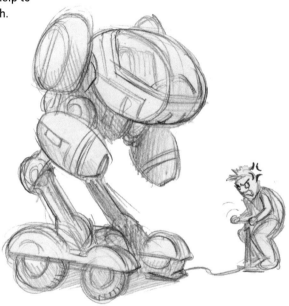

Your Turn

Create an illustration whose primary goal is to be humorous. Rather than go straight into the final artwork, do a number of sketches first to see which layout or point of view is best for presenting the joke.

PREVIOUS SPREAD
The Scavenger
pencil, colored pencil, pastel,
white gouache, computer coloring;
9¼ x 14 inches (23.5 x 35.5 cm).

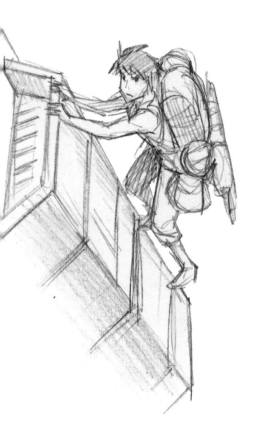

THE SCAVENGER

From the very beginning of my career, I have enjoyed creating highly detailed illustrations. When I first discovered manga, I knew I had found kindred spirits in some of its most famous artists. Many manga, including the aforementioned *Akira* series, feature illustrations so detailed they almost inspire disbelief. *How many hours did this take? No, wait. How many* months?

For this picture, I challenged myself to depict a landscape composed entirely of debris. Happily, a piece of imaginary space junk doesn't need to adhere to any preexisting rules of proportion. No one can tell you that you drew it wrong, because no one knows what it's supposed to look like.

Out of all the art supplies used here, I'd like to call your attention to the pastels. Shaped as they are like pieces of chalk, they don't allow much in the way of precision. But they were well-suited for this project, providing smoky shades of orange-red on the walls and other larger surfaces. They leave a certain slightly gritty look that's hard to match with other tools.

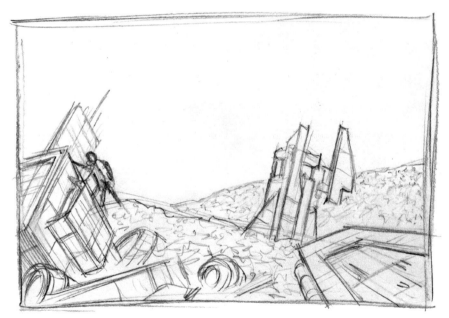

TUNE-UP

Perhaps it's time to admit I have a little obsession with featuring repairpeople in
my sci-fi illustrations! I think it's partly about humanizing science fiction, which
can sometimes portray worlds that are cold and sterile. I like the idea of things still
breaking down in a sci-fi world, just as they do in our world.

This illustration started out as art I created in a YouTube video called "My Illustration
Process." In revisiting the piece, I changed the colors rather dramatically, muting
those of the robot (it was originally a bright yellow), so as to call more attention to the
repairwoman. I also added a few more details (the wrenches, for example). Computer
coloring wasn't a huge part of this illustration, but I found it very helpful for dropping
in the gradient blue of the sky. Such smooth, unvarying color is very hard to do by
hand, but a cinch to do in Photoshop.

Tune-Up
pencil, marker, colored pencil,
white gouache, computer coloring;
5¼ x 8¾ inches (13.3 x 22.2 cm).

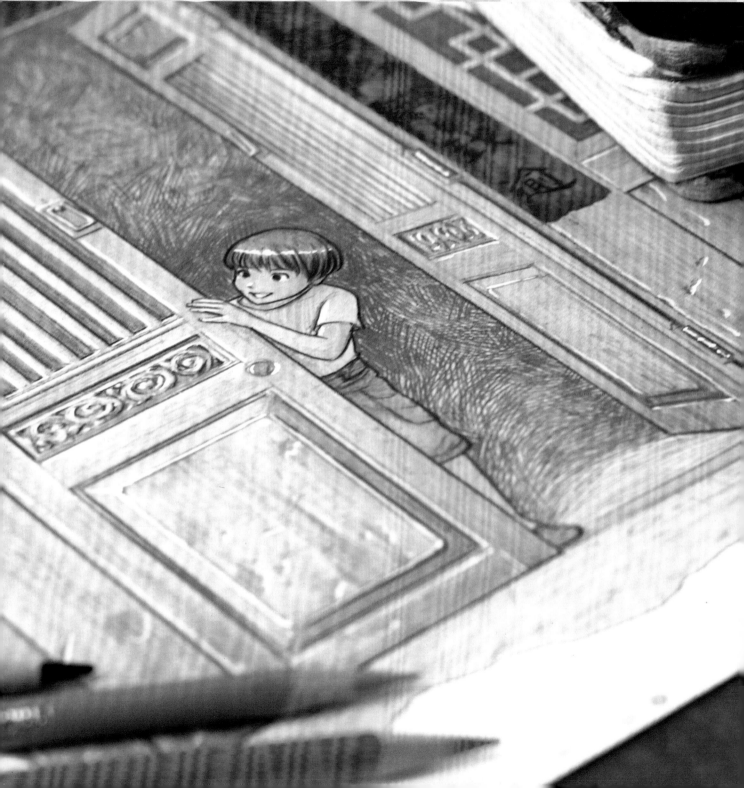

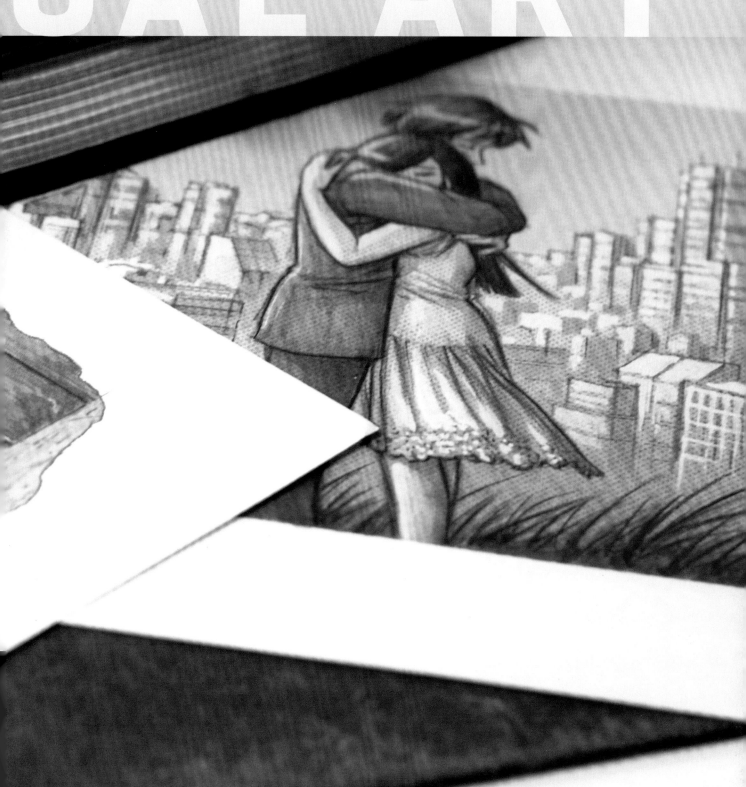

4
CONCEPTUAL ART

Every illustration begins with an idea: *I should try a self-portrait; I think I'll go outside and sketch something in the open air; I wonder how hard it is to draw Luke Skywalker's X-wing?* and so on. Oftentimes a simple idea like one of those just mentioned is all you need to be off and running with your latest project.

Some ideas are more complex though. Each of the pictures in this chapter began with a particular concept, one not so easily summarized as in the examples above. In one case, I found myself wondering about the use of straight lines and right angles in a drawing. Could I do a good illustration that was limited almost entirely to such lines? When you get to that picture on pages 118–119, you can judge for yourself.

When drawing in a manga style, it is a very natural thing to deal with concepts and big ideas, since this approach is at the heart of many of the most popular manga series. Sure, you can find a manga about ordinary students at an ordinary high school, but more often than not it'll turn out to be a high school for vampires, or the Maruyama Academy for Advanced Time Travel.

And so it is that I now devote a chapter of this book to pictures based on unusual concepts. In preparing each illustration, I challenged myself to explore a certain idea as fully as I could: to wrestle with it and get to the bottom of it in visual form.

As a result, each image invites the viewer to step beyond the stage of simply enjoying its shapes and colors. You are encouraged to interpret the picture, to decipher what it's all about. I may have had a certain goal in mind when I created each image, but that's not necessarily what you're going to come away with after looking at it. This artwork can mean different things to different people, and, indeed, I hope it will.

Now, this doesn't mean I got all deep and ponderous every time I put pencil to paper. Most of the concepts underlying these pictures are quite lighthearted, really. One is about the joys of folding paper. Another is a tribute to the delightfully specific world of anime conventions. One is—get this—about a boy who skates with paintbrushes on his feet. For better or

worse, my instincts as an artist lean toward
the whimsical. No one will ever accuse me of being
too serious.

Throughout this book, several of my pictures have a
strong narrative feeling to them, as if they were torn
from the pages of a larger story. This is especially
true of many illustrations in this chapter. It's easy to
start imagining a backstory for them, or to wonder
about what's going to happen next to their featured
subjects. Since none of these stories has yet been
written, you are free to invent any narrative you
please. Chances are, the tales you come up with will
be just as interesting as anything I could cook up.

And so it all comes back to ideas: the ideas I had that
resulted in these pictures and the ideas you'll get
from looking at them. With any luck, one or two of
these pictures will drive your creative instincts in new
directions, sending you off with pencil and paper to
create some conceptual illustrations of your own.

NICE DAY FOR A DRIVE

I'm always eager to set my manga-style illustrations in time periods that one doesn't often see in manga stories. This time I thought, *What happens when you drop a manga character into the world of retro-50s Americana?* If it's already been done before, I've certainly never come across it.

I was inspired by old Alfred Hitchcock films: the kind where you get to see a glamorous-looking Grace Kelly, out for a spin in a gleaming convertible. To give the illustration a sort of "soft focus" effect, I did my initial drawing in pencil and scanned it into my computer without adding ink. I knew from the start I wanted the colors to be classic 50s: pink and minty-cool bluish green.

I'm not sure Grace Kelly would have gone for the fuzzy dice, but come on: it seemed like the perfect finishing touch.

Nice Day for a Drive
pencil, white gouache,
computer coloring;
6½ x 9¾ inches (16.2 x 24.5 cm).

BOOK BOY

Book Boy
pencil, pastel, white gouache;
7¼ x 9¼ inches (18.4 x 22.8 cm).

With this illustration, I wanted to produce a tribute to the joy of reading. I love books, and can only wish I had as much time to read as the lad featured in this picture.

One of the things I'm always up against as an artist is my tendency to keep my lines tight, clean, and under control. This time I was determined to loosen up. I started with sketchy pencil lines and let them stay sketchy all the way to the end.

I then selected a coloring tool that was a little rough around the edges: pastels. I applied each color as loosely as I could, pushing them around with my fingers and making little effort to keep things perfectly within the lines. A bit of white gouache, applied in a similarly quick and spontaneous way, provided the finishing touches.

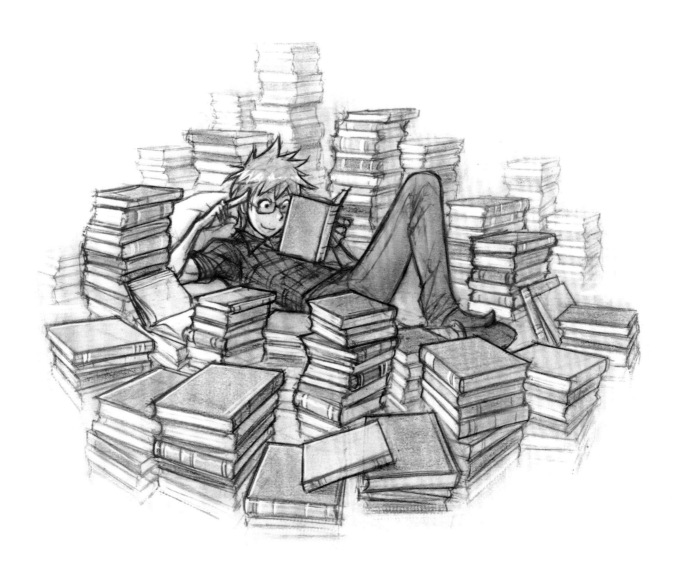

THE WEDDING DAY

When I'm having trouble deciding what to draw, I find it helpful to do an "imaginary commission." I think of a job that someone might hire me to do, and then just go ahead and give the assignment to myself. For this one, I imagined a couple asking me to do a special manga-style illustration for their wedding day.

I looked at manga-style illustrations by other artists, but also studied photos of actual brides and grooms, combining elements from many different sources to create my own ideal couple.

I tried to ink with a light, confident touch, wanting the finished picture to have a clean, effortless look. Similarly, I used simple and subtle computer coloring— a limited number of colors in light shades—allowing the lines to be the focus of the viewer's attention.

The Wedding Day
pen and ink, computer coloring;
10½ x 5 inches (26.5 x 12.5 cm).

Your Turn

Try giving yourself an imaginary commission. Let's say someone needs you to make a birthday card or design name tags for a convention. See what you can do to give these projects a manga-style twist.

One Last Embrace
pencil, marker, white gouache,
computer coloring;
5¾ x 9¾ inches (14.6 x 24.9 cm).

ONE LAST EMBRACE

I adapted this illustration from art I created for a YouTube video called "How to Draw a Cityscape Background." Rather than make this piece a simple drawing of a city, I added a couple in the foreground, in a pose that was itself based on an earlier video I'd made about how to draw people hugging.

But a funny thing happened on the way to finishing this purely instructional "example image." A narrative began to suggest itself. I started to see this piece as featuring not just some random couple, but a couple saying good-bye—perhaps for the last time. The cityscape behind them seemed only to accentuate the drama: to make their story just one among millions, and yet unique.

The art materials used consist largely of pencil, marker, and white gouache. I added a pattern of *screen-tone dots*—tightly-packed rows of tiny dots that the human eye reads as a single field of color—with Photoshop, along with a hint of gradient darkness near the top and bottom of the frame.

TATTOO

There are many types of coloring methods used in this book. With most of them, I endeavored to bring colors and line art together into a seamless whole. For this picture, I wanted the appearance of a silk screen: as if the image came from an earlier decade, when the paper had to go through the press again and again, getting each individual color from a different plate.

The tattoo itself is another example of my fascination with patterns. The lines and shapes were all suggested by the underlying form of the face itself. Though the tattoo is purely abstract, it is composed of carefully chosen shapes. I wanted it to look like the style of a particular culture, with its own aesthetic traditions.

Tattoo
pen and ink, computer coloring;
7½ x 4¾ inches (19 x 12 cm).

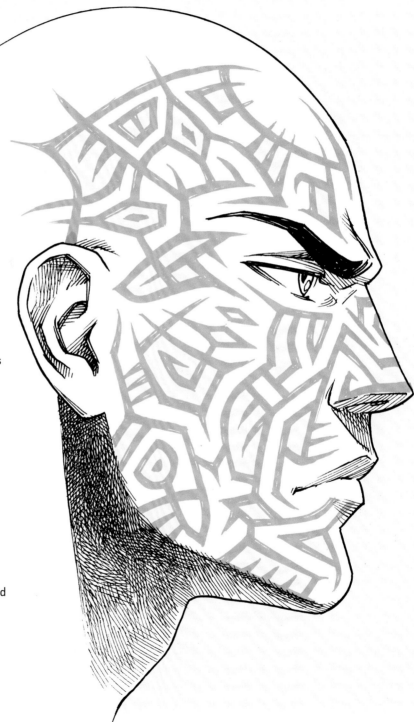

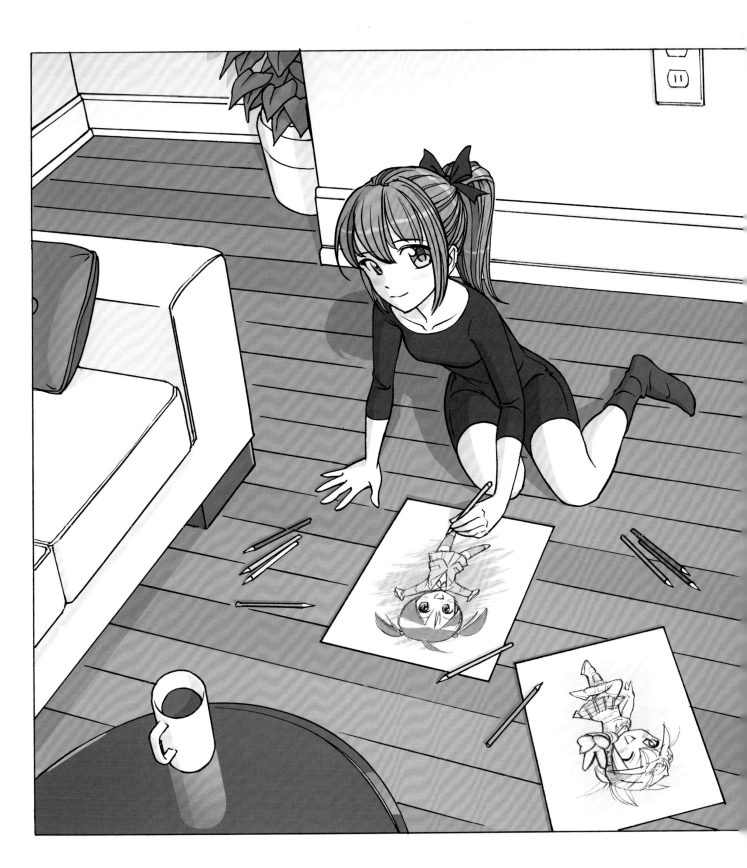

COLOR MY WORLD

One of the first decisions an artist often needs to make is a fundamental one: black-and-white or color? Especially in the world of comics, it tends to be an either/or proposition. So it was that I found myself wondering what a picture would look like if I combined the two approaches.

As I batted around different ideas for how to do it (I briefly considered a doorway from a black-and-white world into a color one, like they did in *The Wizard of Oz*), I hit upon the concept that really captured my imagination: an artist in a black-and-white world who was able to draw in color. From there, I was off and running.

I made my initial drawing with ink on paper. I did all the coloring in Photoshop. The drawings on the two sheets of paper are sketches I did separately, and then moved into position once I'd scanned them into the computer.

HOKUSAI GIRLS

Hokusai Girls
colored pencil, marker,
computer coloring;
5¾ x 6¾ inches (14.6 x 17.5 cm).

I adapted this illustration from artwork I created for a video called "How to Draw Hair." There was something about the initial image that kept calling out to me. It had the potential to be a much better illustration, if I could just put some more time in and take it to a different place.

I took a cue from the hairstyle of the girl on the right, whose lines reminded me of flowing water. Always eager to explore the visual possibilities of patterns, I turned to Japanese artwork to see if I could create a custom wallpaper background. I found what I needed in *The Great Wave off Kanagawa*, the famed image by Japanese printmaker Hokusai. I carefully reproduced Hokusai's wave multiple times until it took on the appearance of wallpaper, then scanned it into Photoshop and added muted shades of blue.

There's a bit more mystery to this image than is the case with many of the others in this book, since it doesn't have so simple an explanation as, for example, the *Book Boy* illustration (page 106). It is not so much about meaning as it is about aesthetics, and the beauty of two elements that united to become more than the sum of their parts.

LADY LIBERTY

For this illustration, I asked myself, *What would the Statue of Liberty look like if it had been designed by manga artists?*

I started with a careful study of the actual monument, then tried to see how much of it I could remain faithful to as I gently pushed things into the realm of manga. The real Statue of Liberty presents a figure buried beneath cloth, much of its torso and all of its legs hidden from view. I figured manga artists would choose a lighter approach, allowing the feet to be seen, and reducing the bulk of the cloth throughout the entire design.

Knowing that I'd have to get that familiar shade of "Statue of Liberty green" just right, I opted for computer coloring, which allows a precision in color matching that's difficult to achieve with traditional art supplies. Though I did the initial drawing in pen and ink, I used Photoshop to alter the color of the line work—green for the body, brown for the base—to make it blend in with the coloring. This is a useful technique you can use any time you want to avoid bold black lines that call a lot of attention to themselves.

Lady Liberty
pen and ink, computer coloring;
11½ x 5¼ inches (29.2 x 13.2 cm).

OPPOSITE
Street Fashion
pencil, pen and ink, computer coloring;
9½ x 4¾ inches (23.6 x 12 cm).

STREET FASHION

I've never been overly concerned about what clothes I wear, so the world of fashion is well beyond my frame of reference. But I'm intrigued by the idea of "street fashion," where ordinary men and women come up with their own daring looks, free from the dictates of whatever clothing empires hold sway at the moment.

For this picture, I started with two figures—drawn with pencil on paper—and proceeded to dress them in the boldest way I could imagine. I wanted their clothing choices to be a weird mix of things that didn't match, and yet somehow held together as a look. Once I was happy with what I had drawn, I inked up the image and scanned it into my computer.

The computer coloring for this piece is probably the most "un-Crilley-like" I've ever done. I was almost deliberately trying to make things clash. To finish it off, I added a bit of faux graffiti in the background, using a Photoshop brush that simulates the look of a spray can.

Your Turn

Break out of your comfort zone. Try tackling a subject matter you've never drawn before, or using colors you wouldn't normally choose. You just might find it leads you to a whole new way of doing things.

The Crane Fold
pen and ink, computer coloring;
8¾ x 7¼ inches (22.2 x 18.4 cm).

THE CRANE FOLD

Anyone who has dabbled with origami will be familiar with the crane fold—the base from which so many paper-folding creations are built. It is probably more accurate to call it a series of folds, for it is in fact composed of a great many steps, and can be quite challenging for the novice. In this illustration, my concept was to pay tribute to the most astonishing step in the crane fold process: the moment where it becomes possible to open up the paper, like the petals of a flower, and press it into an entirely different shape.

I envisioned a world in which little chibi characters could work their paper-folding magic on a giant-size square of paper. By playing with the scale of the creators and their creation, I felt I could present origami to people in a new way. While others may see it as a small art form, to me it has always seemed a massive innovation in the history of human creativity.

I did all of the initial line work with ink on paper, but after that, my computer did all the heavy lifting. Wanting the paper and its folds to have authenticity, I pulled the pattern of an actual sheet of origami paper into Photoshop, and used the software to apply proper perspective to each individual section. The result, I hope, is a picture in which even someone entirely ignorant of origami can perceive the structure of this fold, and imagine how the paper is being transformed from one shape into another.

ESCHER, CONCEPTS, AND ME

When people ask about my artistic influences, I often mention the work of M. C. Escher. My parents took me to see a retrospective of his work at the Detroit Institute of Arts in the summer of 1973. I had just turned seven, so these were very early days for me as an artist, and the impact of Escher's work on my young mind was profound.

At the time, I was mainly impressed with Escher's drawing skills, but with the benefit of hindsight I can see that the conceptual aspects of his work also had an effect on me. Escher's images very often present a single, clearly perceptible idea: a hand drawing another hand; a never-ending staircase; a pattern composed of interlocking birds and fish. It seems Escher rarely began a project with a thought like, *Today I'm going to go out, find a pleasing view of the countryside, and draw it.* If he drew the countryside, you sense that he would inevitably use it as a jumping-off point to begin wrestling with an unusual artistic idea.

Over time, I turned out to have similar artistic instincts. You can find a few landscapes and still lifes among my works, but mainly my art over the years has dealt with tackling one concept or another. In childhood, I drew a picture of an asteroid with a cutaway that revealed it was, in fact, a secret space station. In a college printmaking class, I created the image of a samurai that was half man, half rooster. Later that year, I designed a poster for the school play—a production of *The Shadow Box*—in which I illustrated four hands whose negative space formed the shape of a human skull. (That one was basically too conceptual: it got rejected in favor of something a little less heady.)

In my professional life, much of the art I produce is for graphic novels or for books devoted to art instruction. But underpinning all of it is that core tendency to center my work on some sort of clear idea. For better or worse, I keep following the path that Escher put me on all those years ago, rarely creating artwork that doesn't have some sort of funny little concept lurking behind it.

EVERYTHING IS PERFECT NOW

This piece came as the result of a kind of dare I made to myself: *Can you create an illustration that consists almost entirely of straight lines and right angles?* Once the thought occurred to me, I knew I had to take on the challenge. What would such an illustration look like?

I imagined a man in a sleek, modern office, where everything was incredibly tidy and organized. The furniture, the desk lamp, even the Mondrian-like paintings on the wall: everything is composed of squares and rectangles.

To add a narrative twist, I decided to shatter all the clean lines with a spilled cup of coffee, suggesting that all is not so well with this man, and that his life is perhaps going a little off the rails.

Everything Is Perfect Now
pencil, computer coloring;
6 x 13⅕ inches (15.2 x 33.5 cm).

Your Turn

Challenge yourself to do a drawing with a particular stylistic limitation. I created my piece (above) with mostly straight lines. Maybe yours could be a "curved-line-only" challenge, or an illustration in which all the colors are shades of red. Setting limits like these can help you discover new ways of doing things as an artist.

OPPOSITE
The Sculptor
marker, pastel, colored pencil,
pen and ink, computer coloring;
11 x 14 inches (27.9 x 35.6 cm).

THE SCULPTOR

There were a number of themes I found myself coming back to again and again as I created the illustrations for this book. One of them was the idea of depicting the artist at work. I suppose the process of sitting down to create new art, day after day, week after week, caused me to reflect on the various relationships artists have with their own work.

For this illustration, I had a pretty clear image in my mind from the start: a sculptor chiseling away at a massive manga-style sculpture, a project so huge it made the artist look tiny by comparison. I liked the idea of presenting a work in progress. You can see what the finished piece will look like, but you also see how much remains to be done. It is a tribute to having patience, and to what can be achieved if you have enough of it.

This piece involved almost every art supply in my toolbox. I wanted the tactile scratchiness of pastels and colored pencils, but also the smooth gradations of Photoshop shadows. The computer coloring was especially helpful for conveying the sculpture's rough-hewn surface, as it allowed a subtlety in the application of white crosshatching that would have been hard to achieve with a traditional medium like gouache.

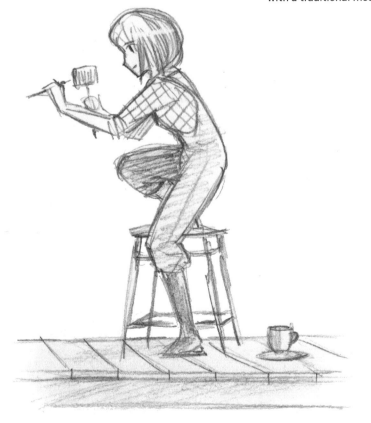

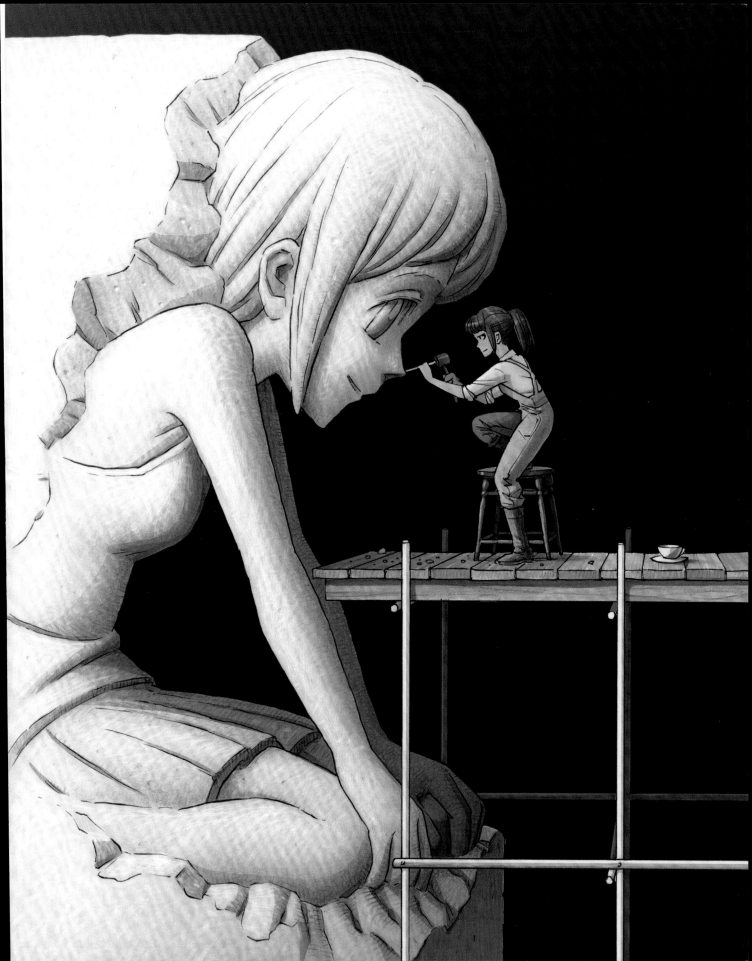

CANDY COLORED

When it comes to identifying works in the manga style, the manner in which a character's eyes are drawn tends to get the most attention. But the depiction of hair is also of primary importance. Manga illustrators have devised a multitude of fanciful ways to draw hair, methods that are entirely distinct from what one sees in Western drawing styles.

In this picture, I wanted to create a celebration of manga-style hair. I began with a pencil drawing of three female characters, then plotted out three different hairstyles that would stand in contrast to one another, yet also be complementary, sharing the same illustrative DNA of gentle waves and long, smooth lines.

I created the initial illustration with pen and ink. I could have chosen any number of coloring techniques, but I soon decided on computer coloring. It produces a look of shimmering, smooth perfection that is difficult to achieve with traditional art supplies.

Once I had the image scanned into Photoshop, I made a point of selecting three different hair colors that don't occur in nature: green, purple, and blue. Such selections are very much in keeping with the manga tradition, in which characters' hair routinely comes in such eye-catching hues. The result is an image of characters who are fresh and fun, free of the obligation to look like "ordinary people."

Candy Colored
pencil, pen and ink, computer coloring;
9⁴/₅ x 5¹/₅ inches (24.9 x 13.2 cm).

The World Traveler
pencil, marker, colored pencil,
white gouache;
7²/₅ x 8¹/₅ inches (18.8 x 20.8 cm).

THE WORLD TRAVELER

When I graduated from college in 1988, I went to Taiwan, kicking off what you might call my "traveling period": six or so consecutive years, spent mostly in the Far East. I wasn't constantly on the road, but by the time 1995 rolled around, I had been lucky enough to visit an awful lot of countries, with experiences along the way that were very eye opening indeed.

With this illustration, I wanted to pay tribute to the thrill of international travel. In a sense, I tried to capture not so much the traveling itself, but rather the excitement of the days leading up to such a trip. There is nothing quite like the rush of going out into the world for the first time, whether it is to seek your fortune or just to see what you can see.

From the start, I knew I wanted to use old-school art supplies for this piece. The rough-and-tumble spirit of world travel called out for the grit of pencil on paper. With the colors, I chose to let the world map be my guide, leading me toward blues and browns throughout the piece. The color red became an important secondary element. Having chosen that color for the path drawn across the map, I found ways of dropping it in throughout the rest of the image.

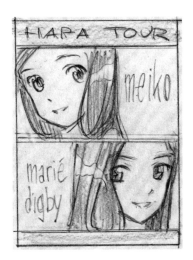

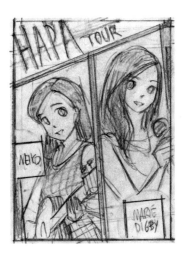

HAPA TOUR POSTER

Making artwork is always a pleasure, but when the illustration needs to serve an unusual purpose, the whole process becomes really interesting. That was certainly the case when singer-songwriters Meiko and Marié Digby approached me to design a poster for their 2016 Hapa Tour. I was already a big fan of their music, and having never been entrusted with such a job before, I was determined to deliver the best work that I could.

The prompt was fairly straightforward: draw Meiko and Marié as if they were manga characters. But a straightforward concept does not necessarily lead to a simple task. I had to do more than my usual prep work to make sure I got things right.

I began by doing rough thumbnail sketches of six different possible designs. My goal was to give Meiko and Marié a chance to weigh in and guide me toward a final design as early in the process as possible. Any illustrator will tell you the last thing you want to do is put hours and hours into finished artwork before showing any of it to your client. If they hate it, you'll have to go back and start all over! Happily, Meiko and Marié looked at all the rough sketches I gave them and settled on a favorite version pretty quickly.

One interesting twist in the project occurred when Meiko pointed out that I'd need to make her guitar red, since that's the color of the one she plays in concerts. Well, it hadn't even occurred to me that I needed to illustrate a specific guitar. I quickly found photo reference of Meiko's guitar, and was thus able to not only make my illustration of it red, but to make it far more authentic in all its various details.

I knew from the start that computer coloring was the way to go for this project, so as to provide the smooth, polished look seen in so many manga-inspired illustrations. Knowing the poster would be seen by music fans all across the country, I tried to make the art as professional-looking as I could, putting extra hours into shading the hair and clothing, and adding white highlights throughout the entire image. My reward was that both Meiko and Marié were entirely satisfied with the finished art—as was I, to be quite honest. And believe me, that doesn't happen as often as I'd like!

OPPOSITE
Hapa Tour Poster
pen and ink, computer coloring;
16²/5 x 11 inches (41.6 x 27.9 cm).

THE HAPA TOUR

MEIKO

MARIÉ
DIGBY

THE CHINESE DOOR

A book of manga-related illustrations very naturally includes artwork that is directly connected to Japan and Japanese culture. Indeed, I've devoted an entire chapter of this book to presenting such illustrations (see chapter 2). But Japan isn't the only country I've visited in East Asia. I taught English in Taiwan for a couple years straight out of college, and for some time, Chinese culture was far more familiar to me than anything that came out of Japan. Taiwan has been populated by Chinese settlers for hundreds of years, and so a visit there is primarily an encounter with Chinese culture, both new and old.

With this picture, I had a very straightforward concept in mind: to capture some of the magic that I experienced in Taiwan in the form of an illustration. One of my favorite sights in the smaller Taiwanese villages I visited was that of traditional front doors on old houses. So I came up with this picture, in which the viewer could encounter one of them, as I would have when I lived in Taiwan: not as an artifact in a museum, but as a part of life—something you could happen to stroll past.

Wanting to present a doorway that was aged and weather-beaten, I chose to build the illustration on a foundation of pencil, avoiding the smoothness of ink. I then moved on to markers for my base color, and colored pencils and white gouache for tightening things up and adding surface details. There's a touch of Photoshop coloring here and there, but this image, like a real Chinese doorway, was created almost entirely from traditional materials.

OPPOSITE
The Chinese Door
pencil, marker, colored pencil,
white gouache, computer coloring;
8 x 10 inches (20.3 x 25.4 cm).

Your Turn

Try doing a manga-style illustration that relates to your own life, or that pays tribute to an experience you've had. By bringing your own memories into your art, you can make your illustrations more personal, and more distinctive from the work of other artists.

THE PAINT SKATER

I've devoted much of my career to using art to tell stories. So much so that even when I sit down to create a stand-alone illustration, it often feels like it was plucked from a comic book page—a brief moment from a longer sequence of events.

Here you see a boy who has turned a pair of scrub brushes into what I'm going to call "paint skates." I liked the idea of a kid creating art while moving around. Indeed, he is creating art *by* moving around.

I want people to not just see the image, but to picture the sequence of events that led up to it. Viewers may first see the boy, then see the brushstrokes on the ground, and then finally notice the paint cans and the bench. Putting it all together, they can imagine the kid sitting on the bench and putting the skates on his feet. In this way, part of the illustration extends beyond the page and into the viewers' imaginations.

The Paint Skater
pen and ink, computer coloring;
11³/₁₀ x 6³/₅ inches (28.9 x 21 cm).

THE SIDEWALK ARTIST

This illustration presents an interesting contrast to my earlier picture, *The Sculptor* (page 121). With that image, I dealt with the life of the professional artist. With this one, I turned to an artist's beginnings: childhood.

For this concept, I wanted to present a picture within a picture. I imagined a boy who loved to draw Japanese-style robots, of the sort one might see in an animated TV series like *Mobile Suit Gundam*. By giving the viewer a bird's-eye perspective, I was able to present the sidewalk as a sort of blank canvas.

From the very start, I knew that colored pencils would be the ideal tools for simulating chalk on a sidewalk. Their slightly rough lines gave me precisely the chalky look I needed. For the grass, where I wanted a more solid expanse of color, I turned to watercolors.

The Sidewalk Artist
watercolor, colored pencil, computer coloring;
11 x 14 inches (27.9 x 35.6 cm).

AT THE ANIME CON

This illustration will be of special interest to those of you who have been to anime conventions. Indeed, the whole concept of the image is to pay tribute to the unique blend of fun, excitement, and general mayhem that one finds at any anime con worthy of the name.

I confess the basic idea of the picture was inspired by an old *Saturday Evening Post* illustration by Norman Rockwell, in which an ordinary woman reading a magazine was given the appearance—by way of the magazine's cover—of having turned into a Hollywood starlet. Beyond this initial visual trick, though, I wanted the picture to be filled with all the various pop culture treasures that one can acquire at an anime con: everything from stacks of manga to stuffed Totoro dolls to cans of Japanese coffee.

Knowing that there would be so many little details, I decided to keep my inking clean and simple, using as few lines as possible. My approach to the computer coloring of the piece was something of a stylistic experiment: I chose to keep the areas of color deliberately flat. The final effect is light and clean, and perhaps reminiscent of a certain type of fine art print. It's not a coloring approach I've tried very often, but I was pleased enough with the results here that I'm sure I'll be making use of it again before very long.

OPPOSITE
At the Anime Con
pen and ink, computer coloring;
10 x 8¼ inches (25.4 x 20.9 cm).

PLAY

5

STYLEPLAY

From my earliest days as an artist, I've always liked challenging myself to draw in another artist's style. It's an enjoyable artistic exercise, and I invariably pick up a few tricks along the way: techniques I can incorporate into my own work. I'm not the only one, either. Many artists try mimicking different art styles at one time or another, whether it's just for pleasure or one of the requirements of a paying gig.

It seems to me that this type of artistic activity deserves its own name, and I've decided to call it *styleplay*. The word is derived from the Japanese word *cosplay*, a combination of the words "costume" and "play." Cosplay describes the phenomenon of people dressing up as popular characters, usually in conjunction with attending a convention of some kind. At its heart is the fun of becoming someone else for a while, just as people do on Halloween.

I feel that taking on the drawing style of different artists has a very similar spirit. Both activities bring a special kind of joy: whether you are dressing up as Kiki from the Miyazaki film *Kiki's Delivery Service*,

or you are trying to draw Kiki exactly as the animators did for that movie. But my invented word "styleplay" is meant to describe something a bit different from drawing famous characters. It's about drawing your own character(s), but in someone else's style.

Now, let's be clear: I'm not advocating the idea of devoting your entire career to the imitation of some other artist's style. That's just kind of sad. And yes, you should strive for your work to be a unique expression of who you are as an artist. But every once in a while, just for fun, or for the purpose of learning new things, I think there's no harm in doing styleplay illustrations.

In the pages ahead, you'll see me doing pictures inspired by artists as diverse as Gustav Klimt, women's fashion illustrators, *Calvin and Hobbes* creator Bill Watterson, and the people who design playing cards. You'll see carefully drawn lines, and lines that were slapped down as fast as I could. You'll see faces that are quite close to real human anatomy, and faces that are as cartoony as they

come. What you'll see, really, is me having fun as an artist: trying drawing methods I've never tried before, and pushing myself to my artistic limits.

By the time you get to the last page, you may find yourself itching to try a styleplay illustration of your own. Heck, you may even wonder if that was my ulterior motive all along. I will neither confirm nor deny. But if you do decide to give it a try, rest assured I'll be over here cheering you on every step of the way.

THE GIRL WITH THE GUN

Doing a styleplay illustration is all about trying on a different artistic persona. So why not take it one step further, and try on someone else's career? That was my thinking as I sat down to create this manga-style version of an old pulp fiction paperback cover. I knew I'd have fun imitating the illustration style, but what I really looked forward to was the chance to emulate all the other elements: the lettering, the layout, the pun-laden tagline, and the simulated weather-beaten surface of the cover.

I started with pen-and-ink illustrations of the figure and the background buildings, then scanned both into Photoshop to start playing around with them digitally. By consulting photo reference of actual crime novels published in the 1950s, I learned how to get the look I wanted: detailed and fully rendered art in the foreground, superflat and simple art in the background. The scuffed-up surface blemishes came from a scan of my old paperback edition of *The Catcher in the Rye*, dropped in on top of the art after everything else was done.

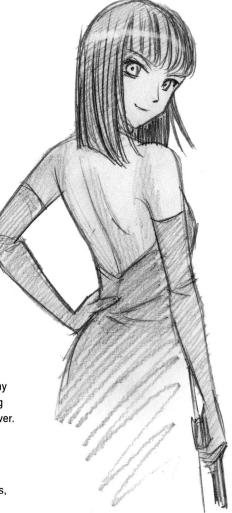

OPPOSITE
The Girl with the Gun
pen and ink, computer coloring;
7½ x 5½ inches (19 x 13.9 cm).

A Village in England
pencil, colored pencil,
computer coloring;
4½ x 8½ inches (11.4 x 21.6 cm).

A VILLAGE IN ENGLAND

As styleplay goes, this piece is considerably closer to my usual drawing methods than others in this chapter. But I did go outside my comfort zone in regards to the character's facial proportions, placing the eyes extremely low on the head. Once you've had it pointed out to you, you can't help noticing it: the area of her hair is quite massive compared to her facial features. The result is a look of great youthfulness, as such proportions are a little reminiscent of those seen in babies.

I began the drawing in pencil, applying colored pencil in the areas where I wanted the blacks to be their blackest: the eyes and the shaded areas of her hair on the left. In the background, I left all the lines quite light, especially toward the center of the drawing. This served the dual purpose of making that part of the background appear more distant, as well as creating maximum contrast with the foreground figure.

As for the facial proportions, well, I find the look is a touch too exaggerated for me to use on a regular basis. I'm glad I tried it, though. You never know what techniques you'll like until you test them out.

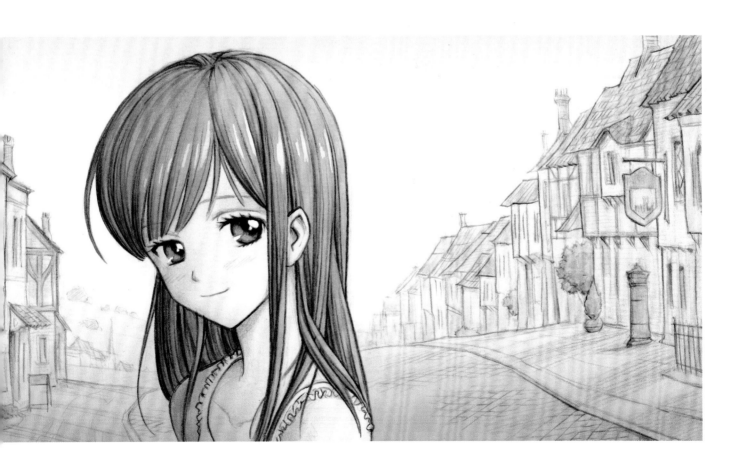

THE BEIGE UMBRELLA

You might not know it from looking at the final result, but this was actually a pretty challenging illustration for me to do. Not so much in terms of the time needed to complete it; the hard part was forcing myself not to add detail. My instincts generally lead me to make things look three-dimensional: to make them "pop off the page" to some degree. For this illustration, I commanded myself to break away from those old habits and do something with the absolute minimum of lines, shapes, and colors.

I started with a pen-and-ink illustration, rendering the coat as a single area of black, even going so far as to have the woman's left arm blend seamlessly with the coat behind it. Then I scanned the image into Photoshop and added colors, eventually settling on just two very pale hues that wouldn't call much attention to themselves. It is surely the most minimalist of all the illustrations in this book. And I'm proud of it, insofar as it opens the door for me to try similar pictures in the future.

The Beige Umbrella
pen and ink, computer coloring;
9½ x 5½ inches (24.1 x 13.9 cm).

Somersault
pencil, pen and ink, computer coloring;
4 x 12½ inches (10.1 x 31.7 cm).

SOMERSAULT

Most of the published manga you find in American bookstores is aimed at a teen or young adult readership. However, in Japan there are manga for every possible age group. I wanted to see if I could do an illustration that would be right at home in a book aimed at the very youngest audience: preschoolers. For me, that meant putting myself into an innocent frame of mind, where even something so simple as a somersault could be presented as a pretty big deal.

Once again, I found myself wanting to loosen up and get some energetic lines on the page. My goal was to keep the rough preparatory lines in the final illustration

to some degree, rather than seek to eliminate them. It seemed especially appropriate for this picture, in which I attempt to convey motion on the page.

For the coloring, I scanned the art into Photoshop, but tried to keep the loose approach going. Using the digital paintbrush settings, I could simulate a handmade, spontaneous look, with colors dashed into the right general area but not rigidly locked within the lines. In a way, the subject matter itself determined my whole methodology on this picture: I knew the art needed to be as fun and as lively as a little boy doing a somersault.

Your Turn

Try doing a drawing that conveys motion by presenting various stages of a single action. Do your best not to have the character seem stiff or locked into place. Allow your lines to become loose and energetic.

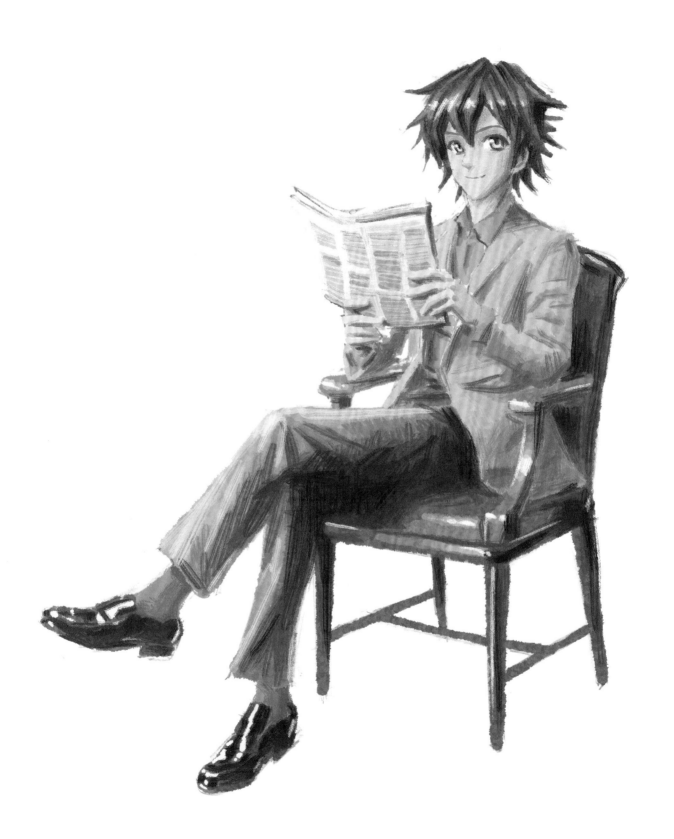

MORNING PAPER

I've colored things digitally for many years, but the use of a Wacom pad and stylus is a relatively new method for me. With this illustration, I challenged myself to make full use of the stylus's ability to simulate brushstrokes. Indeed, I decided at the outset that there would be no visible line art in the final piece.

I started with a simple pencil sketch, scanned it into the computer, and began improvising colors on top of it in Photoshop. I had some sense of where I wanted the lights and darks to be, but otherwise it was a superloose trial-and-error process. And when it comes to creating artwork with the potential for errors, let me tell you: digital is the way. If there was any stroke of the stylus that didn't go the way I wanted it to, I could undo it for a second, third, or fourth attempt immediately.

I enjoyed the experience, but rest assured I'm not ready to throw my real brushes in the trash bin just yet. No doubt I will continue as I always have, making use of digital and traditional methods alike.

OPPOSITE
Morning Paper
pencil, computer coloring;
7¼ x 6 inches (18.4 x 15.2 cm).

ROLLERBLADER

I have always admired artists who draw with loose, confident lines, and have even envied them a little, to be honest. With such lines laid down at a tremendous speed, the artist must execute them with great self-assurance. Throughout this book, you can find illustrations in which I forced myself to draw more loosely than I normally do. But this superloose styleplay illustration is the ultimate example. I dashed very nearly every line in it onto the page as quickly as I could.

I chose rollerblading as my subject since it seemed to go nicely with the idea of committing to swiftness. Starting with just a few basic pencil lines in place, I went to pen and ink as early in the process as I could, pressing myself to make every single line quickly and without hesitation. Once I was satisfied, I scanned those lines into Photoshop and used my stylus to add the colors in a similarly loose fashion. There wasn't so much in the way of computer manipulation, with one exception: I isolated the lines of the background buildings so as to lighten them and make them appear more distant.

Rollerblader
pen and ink, computer coloring;
7½ x 8¼ inches (19 x 20.9 cm).

THE GIRL WITH
THE ORANGE SCARF

Let's face it, I'm a bit of a softy when it comes to art.
There's not so much in the way of darkness in this book,
and certainly no blood and guts or anything like that.
My instincts generally lead me to produce a gentle kind
of art, decorative in approach, designed to please the
eye and give you a good feeling about the world. Still,
I'd have to call the illustration on this page one of my
styleplays. Soft as I sometimes go, this one is softer
still. It has a children's picture book feeling to it, and is
utterly unconcerned with light and shadow: things that
normally obsess me.

You will read me confessing to a bit of digital trickery
in the watercolors on other illustrations later in this
chapter (pages 154 and 161), but I'm pleased to
report the paint on display in this one is the real deal.
I achieved the fuzziness of the colors seen here by way
of wetting the paper with water right before applying
the paint. This method caused the color to spread a bit
before settling and drying into the page. Using colored
pencil for all the lines contributes to the lightness
of the image. My style or not, I like it. And I bet I'll use
these methods again soon.

The Girl with the Orange Scarf
watercolor, colored pencil,
computer coloring;
7¼ x 3¼ inches (18.4 x 8.2 cm).

OPPOSITE
Fish Rider
pen and ink, computer coloring;
11½ x 12 inches (27.9 x 30.5 cm).

FISH RIDER

Here is another styleplay where the target style is not so easily categorized. What I had in mind was the kind of preparatory art created in connection with certain Hollywood movies: the sort that artists make so that film directors can better envision what a particular scene will look like. Such images are often needed for sequences that rely heavily on special effects. As I tried to come up with an imaginary film I might create such art for, I hit upon the idea of an undersea adventure featuring a tiny society of "fish riders," people who use fish as their preferred mode of transportation.

I used photo reference to get the details of the fish right, and even looked at horseback saddles to lend some authenticity to that part of my illustration. Computer coloring was a crucial part of finishing the image. It allowed me to render the watery background with a level of smoothness that would have been almost impossible to achieve with any traditional art tool. It was also a huge time saver in the area of the bubbles. I was able to add them with a few strokes of a Photoshop brush, rather than painstakingly draw one bubble at a time.

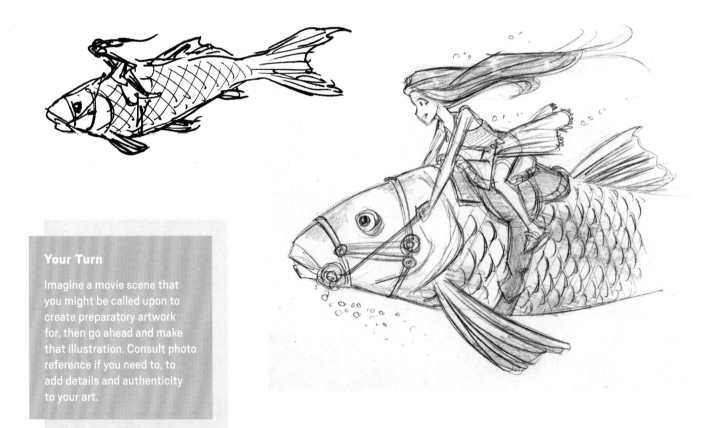

Your Turn

Imagine a movie scene that you might be called upon to create preparatory artwork for, then go ahead and make that illustration. Consult photo reference if you need to, to add details and authenticity to your art.

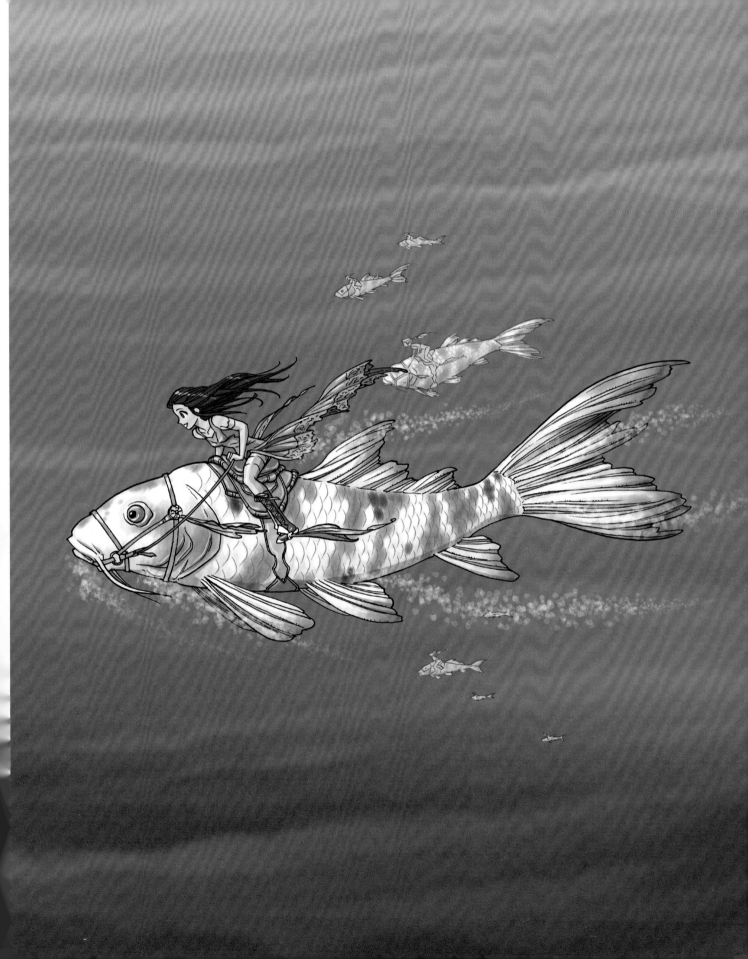

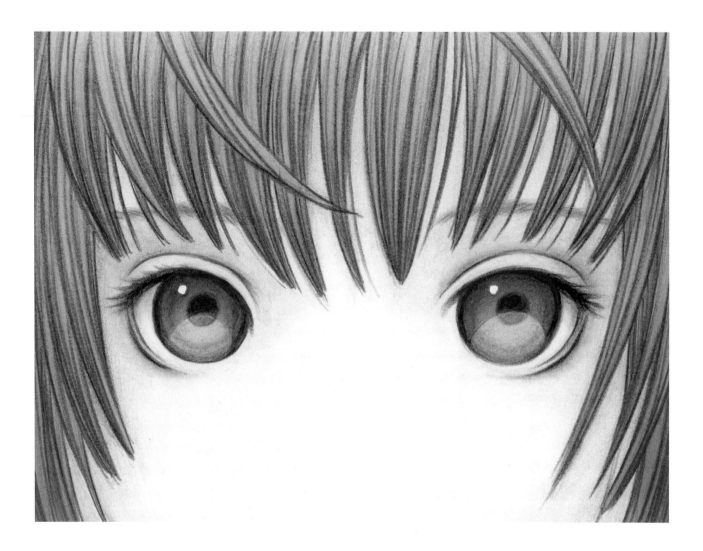

Murata Eyes
pencil, colored pencil,
computer coloring;
4½ x 6 inches (11.4 x 15.2 cm).

MURATA EYES

This illustration began life as a piece of art in one of my YouTube videos, "Pretty Eyes, Mellow Music." I'd always been rather fond of it, and felt it could be a memorable picture with a bit more work. It is certainly a fine example of styleplay, in that it involves me emulating the drawing style of the Japanese illustrator Range Murata, especially his approach to drawing eyes. Murata gives his characters perfectly round irises, with just one tiny white highlight near the pupil of each eye. It's a big part of what makes his characters so haunting and beautiful, and it's well worth studying if you'd like to achieve similar effects.

I did the original illustration with pencil and black colored pencil. In revisiting it, I added more detail to the eyes and especially to the hair. After scanning the image into Photoshop, I darkened the hair and irises just a touch to create more contrast. If you like the look of this illustration, make sure you check out the work of Range Murata. He is truly a master illustrator.

LITTLE GREEN CHIBI HOOD

In a certain sense, drawing chibi characters is always a type of a styleplay for me. My published comics haven't involved chibi illustrations, so I haven't completely ingested the style as I otherwise would through daily repetition. In this picture, though, there's an added aspect of pushing myself into a simplified, polished drawing method that's a bit more smooth and streamlined than what I normally do. It's the type of illustration I might expect to see on a consumer product or a T-shirt.

I started with a pencil sketch, then inked the lines, taking great care to execute every line with a smooth, confident stroke of the pen. Any time you go over lines a second time, they become slightly irregular; this is fine for a great many drawing styles, but problematic when your goal is smoothness. After scanning the image into Photoshop, I stuck with the smooth approach, using clean, untextured blocks of color, and just a hint of shading along the right-hand side of the art.

Little Green Chibi Hood
pen and ink, computer coloring;
6 x 4½ inches (15.2 x 11.4 cm).

Your Turn

Make a pencil drawing of anything you like, keeping the lines light and loose. Then practice inking it. Try to make every line just a single stroke, without going back over it a second time. See if this method helps you get a more professional look.

The Chibiest Chibi
pencil, colored pencil,
computer coloring;
4¾ x 4¼ inches (12 x 10.7 cm).

OPPOSITE
Cat Girl
pen and ink, computer coloring;
10¼ x 6¾ inches (26 x 17.1 cm).

THE CHIBIEST CHIBI

The first thing you notice when you look at a chibi character is that the head is bigger than the body. But how much bigger? My approach is usually something like you saw in the *Little Green Chibi Hood* illustration (page 149). Some artists prefer a rather more extreme method, in which the head is so big it dwarfs the whole rest of the body. For this styleplay, I wanted to have a goat this very "chibiest of chibis" approach.

It certainly involved breaking with my own instincts. When you draw the body this small, it seems incapable of supporting the head's weight! But such matters of physics are of no concern when you enter into a realm of extreme stylization such as this.

In keeping with the simplicity of the image, I limited my materials to mostly just pencil, going over the outlines with a black colored pencil. I used Photoshop to help darken the hair a bit, and to tint the entire image purple.

CAT GIRL

The world of manga is filled with all sorts of interesting traditions. Among them is the idea of the "cat girl," a female character who is mostly human, but who has cat ears and a cat's tail. Since I don't draw such characters very often, this illustration became a sort of styleplay exercise right from the start. The whole idea seems quite playful to me, so I decided to keep my picture light and fun.

Wanting the final art to be quite smooth, I used pen and ink for the line work, then scanned the image into Photoshop to apply all the colors. The key to making shiny-looking hair is found in all those little white highlights, as they signify light glinting off the hair. I had my work cut out for me with this character, as the multiple strands of hair required many more highlights than a short-haired character would need. To balance out this element, I made the stockings, as well as the shoes, a bit glossy.

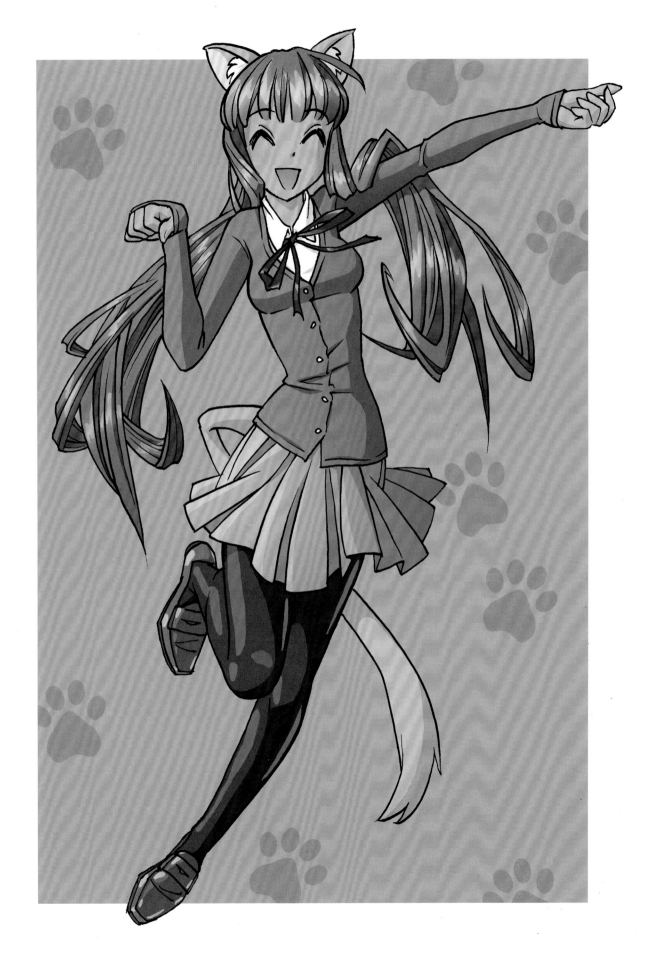

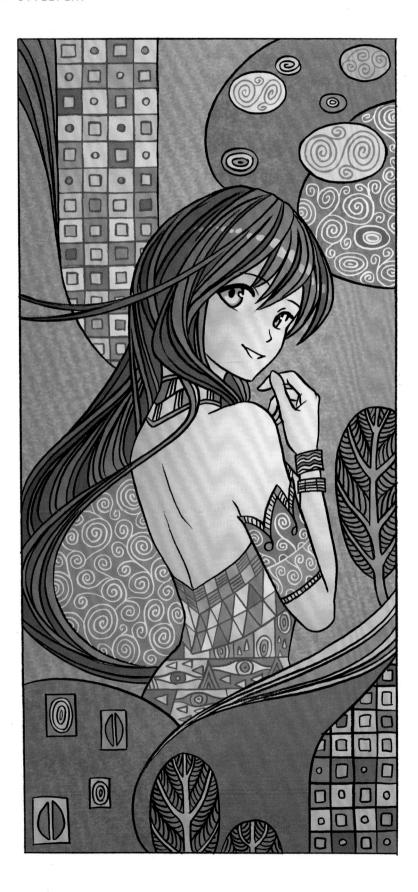

MANGA KLIMT

When I chose to do a chapter devoted to styleplay, one of the first styles that popped into my head was that of Gustav Klimt, the great Austrian painter. Not only is Klimt's style beautiful and immediately recognizable, it also includes the use of patterns, which by now you know have always fascinated me. Klimt's paintings are distinctive in the way they embrace the use of decorative elements. When viewing his work, you feel that the little ornamental squares and swirls are just as important as the figures they surround. I studied a number of Klimt paintings before getting started, to better understand the particular elements he tended to use.

As I began penciling out my composition, I found myself taking a lot of cues from the character's hair, repeating its curves throughout the image. After going over the lines with ink, I scanned the art into my computer and set to work choosing Klimtian shades of gold and blue. Many of the lines that I'd drawn in ink—such as the swirling patterns to the left of the figure's back—needed to be isolated so that I could change them from dark to light.

I must say, this was one of my most productive styleplay experiences. It forced me to try new things, and taught me a whole new way of creating art. Best of all, it gave me an even deeper appreciation of Klimt's work, as it caused me to study his methods more carefully than I ever had before.

Manga Klimt
pen and ink, computer coloring;
13 x 6¼ inches (33 x 15.9 cm).

PARIS IN THE SPRINGTIME

As I said earlier, I've never been very particular about what clothes I wear. But I've always been struck by the unique tradition of fashion illustration: those bold, elongated figures one sees on a shopping bag at Lord & Taylor, or other similar stores. These pictures follow rules all their own, with their creators seemingly more interested in conveying a lighter-than-air artsy vibe than actually showing what the clothing looks like when worn by real human beings. I knew I'd have lots of fun taking this approach on as a styleplay.

I worked the initial pose out in pencil, then did the final lines with a black colored pencil. This was definitely a "do each line with a single stroke" kind of project. Indeed, the whole spirit of a fashion illustration is in the line work. These long, flowing lines put across all the elegance and European flair that these illustrators are going for. In the coloring stage, for a bit of watercolor simulation, I turned to an app called Waterlogue, which takes pictures and digitally transforms them into images that look very similar to actual watercolor paintings. Rather than keep all the colors neatly within the contours of the line art, I deliberately allowed the hues to seep out beyond the lines for a soft, misty look.

Paris in the Springtime
pen and ink, computer coloring;
9¼ x 5¼ inches (23.5 x 13.3 cm).

STYLEPLAYS IN MY *AKIKO* SERIES

There's no question that out of all the published work I've ever done, my *Akiko* comic book series for Sirius Entertainment was the one that allowed me the greatest creative freedom. The only person I really answered to was the head honcho, Robb Horan, and his mantra was "You're the artist. You know best." As a result, I was at liberty to do whatever I felt like doing with every issue.

One place where I made full use of that freedom was on the back cover of each issue. It was there that I first started doing the sort of illustrations I would eventually come to call styleplays. One was inspired by the aforementioned Miyazaki film, *My Neighbor Totoro*. I took my characters, Akiko and Poog, and put them into a location from that movie, doing my best to capture the lush artistry of a Studio Ghibli background.

After that, I was hooked. I did a styleplay of my character Mr. Beeba as if he'd been painted by Vincent van Gogh. I did one of Spuckler in the manner of an old Japanese woodblock print. I did one imitating a full page of Winsor McCay's classic comic strip *Little Nemo in Slumberland*.

(That one took a while, let me tell you.) Fans loved them, Sirius Entertainment loved them, but no one loved them more than me. I just had so much fun creating them. And with each one, I learned new tricks, new techniques, and new ways of creating art.

The *Akiko* series had quite a long run—fifty-three issues—considering it was never going to be a title on the level of *Spider-Man* or *Spawn*. When it finally wound down around 2004, that was pretty much the end of my published styleplays. With the books that followed, *Miki Falls* and *Brody's Ghost*, I couldn't play fast and loose with the cover art, front or back. I kind of figured I'd never get to have such illustrations published ever again.

Which brings us to the book you're holding in your hands right now, and the fact that it contains the largest collection of published styleplay illustrations I've ever been allowed to do. What a pleasure it's been to create a whole new series of such pictures, one after the other. I sincerely hope you have as much fun viewing all these images as I did creating them.

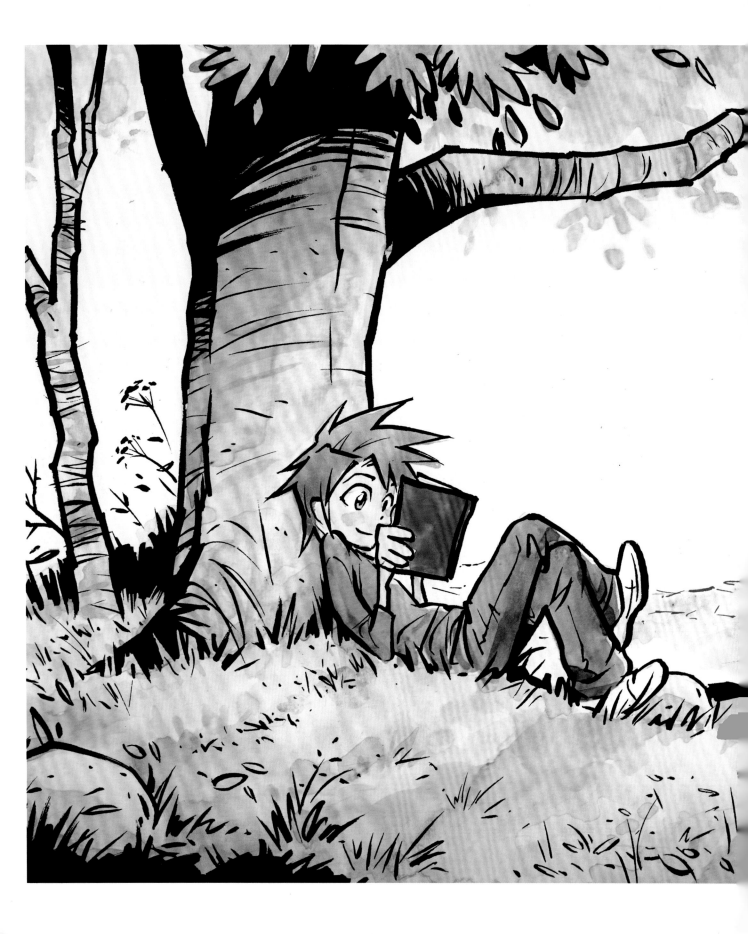

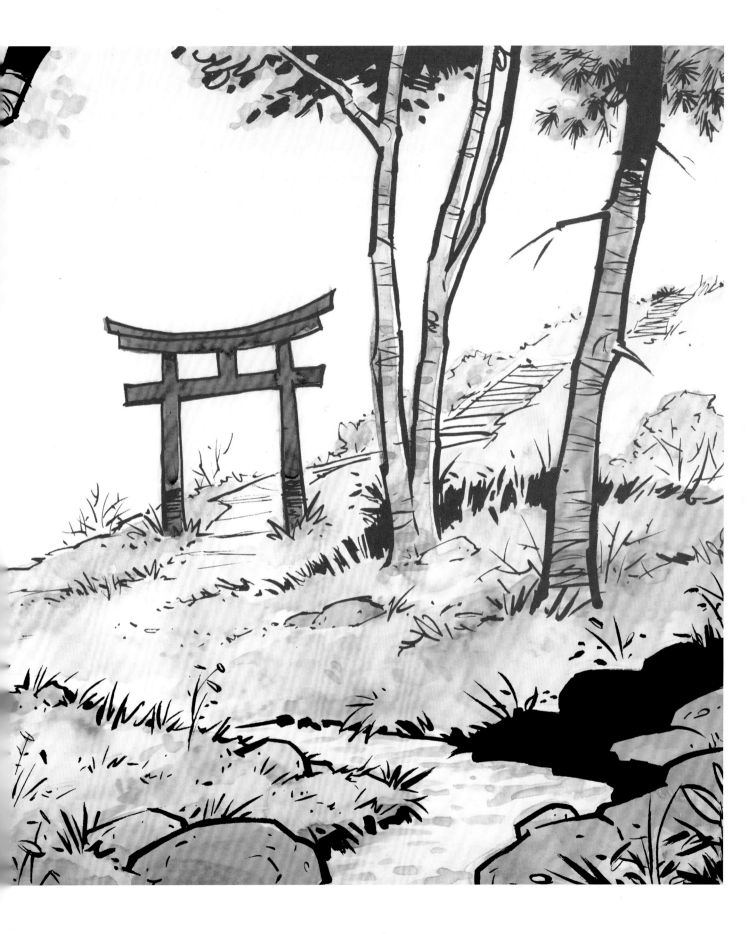

THE WATTERSON TREE

I am certainly not alone in admiring Bill Watterson's masterful comic strip *Calvin and Hobbes*. And as much as I love that strip's characters and Watterson's writing, it is his artwork that I am most in awe of. Watterson truly reinvented what was possible in newspaper comic strips, especially in the longer, full-color installments that ran on the weekends. So it didn't take me long to get started once I hit upon the idea of a manga-style Watterson homage. At the very least, I knew I'd pick up some great tricks for drawing trees!

Knowing that all the *Calvin and Hobbes* inking was done with a brush, I set my pens to one side and did the majority of my line work with brush and ink. This resulted in much thicker lines than I normally create, and large areas of jet-black black as well. I did watercolors on a separate sheet of paper and joined the two elements in my computer using Photoshop. Doing so allowed me to keep the lines nice and black, and also to tweak the hue of the watercolors without affecting my inks. I must say I felt a little schooled by this styleplay. My picture is all right, but it's nothing compared to something done by Bill Watterson.

PREVIOUS SPREAD
The Watterson Tree
brush and ink, watercolor,
computer coloring;
7¼ x 14 inches (18.4 x 35.6 cm).

PUNKY PINK

For me, a styleplay drawing doesn't have to be
specifically about imitating a particular art style that's
out there in the world. It can be as simple as taking your
own style and pushing it in a new direction: making
choices you wouldn't normally make, using colors you
wouldn't normally use, and so on. For this drawing,
I wanted to explore a sort of fashion model version of
punk, mixing symbols of toughness (skulls, chains,
spikes) with colors that are often regarded as not very
tough: pinks and purples.

I decided to keep my lines a little rough and scratchy.
In order to achieve this look, I let a black colored pencil
take the place of ink. My pink markers are always the
last to dry out: I hardly ever use such neon-bright colors
in illustrations. However, they proved the perfect shade
for this character's hair. This illustration's coloring is
almost entirely traditional, with two notable exceptions:
I used Photoshop to add a gradient color fade—from
dark to light—in the purple of the jeans and in the blue
of the jacket sleeves.

Punky Pink
pencil, marker, colored pencil,
white gouache, computer coloring;
10½ x 3½ inches (26.7 x 8.9 cm).

Your Turn

Challenge yourself to use colors you don't
usually use. For example, if dark green isn't
normally your thing, do an illustration in
which dark green is one of the main colors.
An artist should always experiment with
moving into unfamiliar territory.

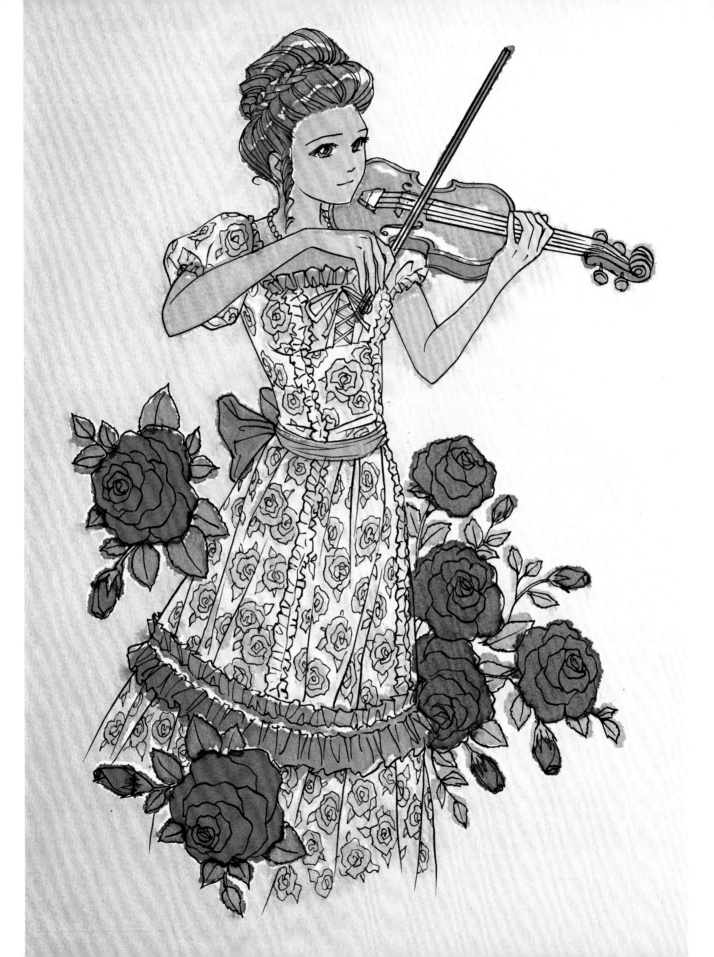

SHOUJO VIOLINIST

Very often the most fundamental aspect of a drawing style is its line work. Thick lines or thin? Rough lines or clean? Only when you can analyze the lines and understand how they were produced can you adopt the style and put your own spin on it. Shoujo illustrations—those generally aimed toward a female audience—tend to be composed entirely of thin, delicate lines. My goal with this styleplay was to produce such lines myself.

Once I had my drawing worked out in pencil, I used a fine-tipped inking pen to go over all the lines. Speed was not as important as care: I had to maintain a consistently light touch, never applying any more than the bare minimum of pressure. Flowers are a staple of shoujo manga art, adding a decorative element to any illustration in need of a romantic touch. The watercolor effects are a bit of a cheat, I confess. I did all the colors in marker on a separate sheet of paper, then used an app called Waterlogue (see page 154) to change them into a "faux watercolor," all executed digitally with a touch of a button.

MANGA QUEEN OF HEARTS

Normally, I draw with a pretty tightly controlled line, so it's not very often I find myself wanting to tighten things even further. But such was the case with this styleplay, in which I challenged myself to do a manga version of a classic playing card. The lines of such an illustration are superclean and precise, not unlike those of a woodblock print from centuries ago. Since the design involved an exact repeat of the artwork rotated 180 degrees, I needed to create an image that would "fit into itself," almost like a jigsaw puzzle piece.

I did the entire top half of the image very carefully in pencil, then scanned it into the computer for a test rotation. This way I could try fitting the two pieces together and tweak any inaccuracies before doing the final inks. Once I completed the inking, I took the line work into Photoshop and added colors, studying actual playing cards to emulate the four-color process that many of them use.

OPPOSITE
Shoujo Violinist
pen and ink, marker, computer coloring;
9½ x 6½ inches (24.1 x 16.5 cm).

Manga Queen of Hearts
pencil, pen and ink, computer coloring;
7¾ x 6 inches (19.7 x 15.2 cm).

OPPOSITE
Water Lilies
pen and ink, computer coloring;
12½ x 9¾ inches (31.7 x 24.8 cm).

WATER LILIES

I couldn't resist saving this piece for last. Monet's water lily paintings are among the most beloved images ever painted, and it's no wonder: few oil paintings can match them for pure unadulterated beauty. Part of what made his works such visual feasts for the eyes was his way of gradually building up layers of paint. Look at a 2-inch square of almost any Monet painting, and you'll find dozens of hues, all brushed one atop the other to form a brilliant tapestry of color. So as a sort of "ultimate styleplay," I set myself to the challenge of trying to re-create one of these amazing paintings within an illustration. (In a sense it is a double tribute, as it is also indebted to one of Norman Rockwell's great *Saturday Evening Post* covers, *The Connoisseur*, in which a gray-suited gentleman contemplates a Jackson Pollock painting.)

Having done a fair number of real oil paintings in my life, it was fun using digital tools— my Wacom pad and stylus—to simulate the look of oil paint in Photoshop. There is a liveliness to Monet's brushstrokes that can only be imitated by way of quick, confident movements of the stylus. Of course I had the benefit of an "undo" button, but I didn't really use it all that much, to be honest. It was more about building up layer after layer of digital paint, working into the surface again and again until it finally became an echo—however faint—of Monet's monumentally gorgeous painting style.

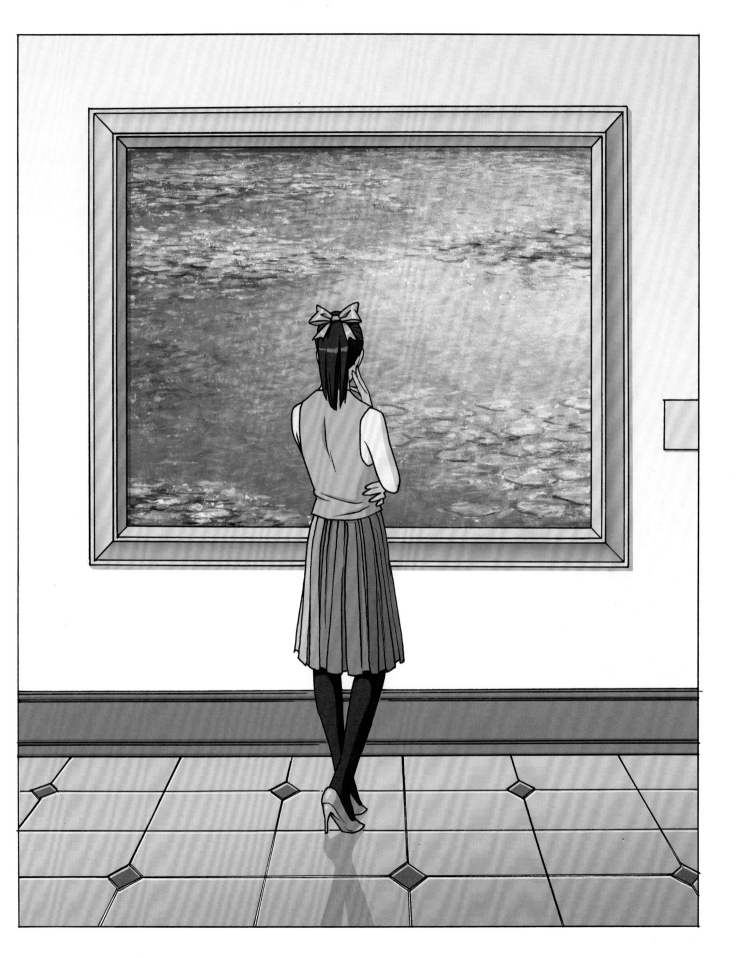

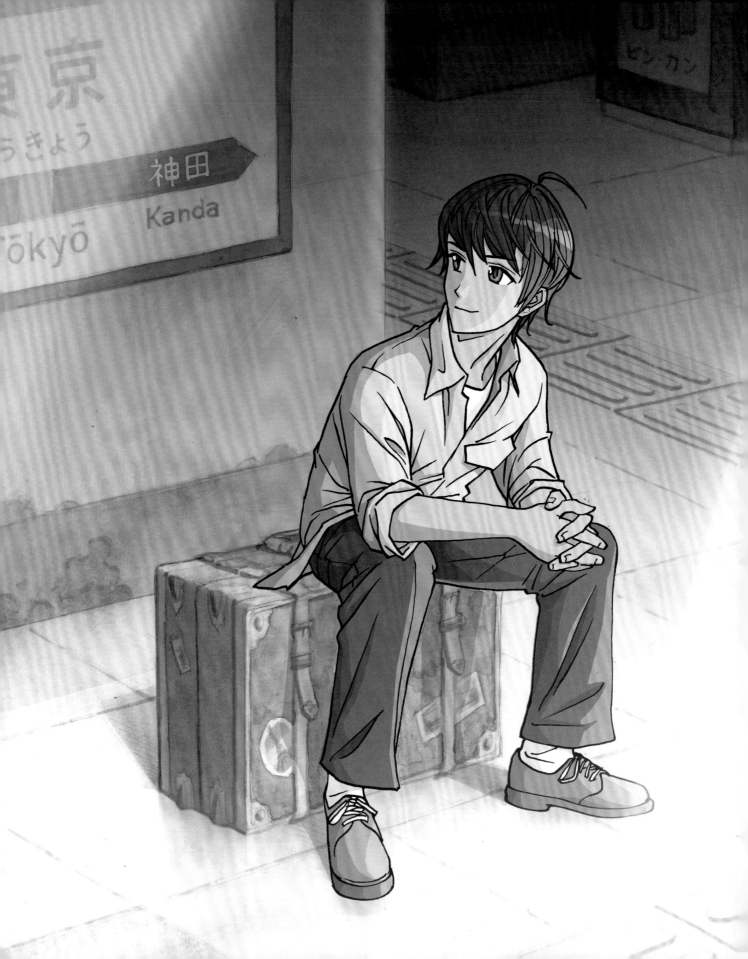

CONCLUSION

I've made many books over the years, and each of them involved the creation of an awful lot of artwork. I couldn't begin to count the illustrations I've done since I first got a publishing deal. The number would be in the thousands, for sure. But in a certain sense, this is the book in which I finally got to be an artist.

In this book, I had the chance to create art that had no other job to do besides simply being a piece of art. It was an opportunity that was a little intimidating, I must admit. *Did I have what it takes to create "real art"?* Well, I suppose the jury's still out on that question. But I can say this: creating the art you see in this book was a gloriously freeing experience for me. I do wonder if I'll ever have such an opportunity again.

Looking back over all these illustrations, there is one that now strikes me as purely autobiographical: *The Sculptor*. In that picture, I showed an artist chipping away at a statue that has taken who-knows-how-many hours so far, and will require who-knows-how-many more to complete.

Is it worth it? Will people like it? Or hate it? The sculptor is not focused on such matters. She's wrapped up in the process. Creating things is fun. That's all there is to it.

On my good days, that's me. And so it is, I sincerely hope, for all of us—whether you're painting a canvas or doodling on a scrap of paper, composing a symphony or whistling a little tune. Making something is more interesting than not making something.

Maybe that, in the end, is what this is book is all about—reminding people how fun it is to make stuff. If you're one of those creative types who haven't actually created anything in a while, please let this book inspire you. Go make something. Right now.

Don't ask if it's worth it. Don't worry whether people will like it or hate it. Just make it, and enjoy the process of making it.

Creating things *is* fun. That's all there is to it.

INDEX

All rights reserved.
Published in the United States by Watson-Guptill Publications, an imprint of
the Crown Publishing Group, a division of Penguin Random House LLC, New York.
www.crownpublishing.com
www.watsonguptill.com

WATSON-GUPTILL and the WG and Horse designs are registered trademarks
of Penguin Random House LLC.

Library of Congress Cataloging-in-Publication Data
Names: Crilley, Mark, author.
Title: Manga art : inspiration and techniques from an expert illustrator /
 Mark Crilley.
Description: First edition. | Berkeley : Watson-Guptill Publications, 2017. |
 Includes index.
Identifiers: LCCN 2016036742 |
Subjects: LCSH: Crilley, Mark—Themes, motives.
Classification: LCC NC1764.5.U62 C752 2017 | DDC 741.6092—dc23
 LC record available at https://lccn.loc.gov/2016036742

Trade Paperback ISBN: 978-0-385-34631-3
eBook ISBN: 978-0-385-34632-0

Printed in China

Design by Betsy Stromberg

10 9 8 7 6 5 4 3 2 1

First Edition